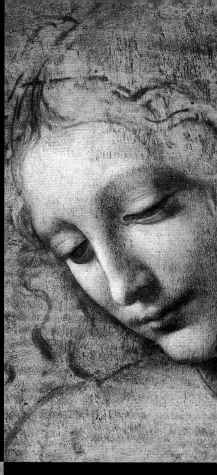

LEONARDO

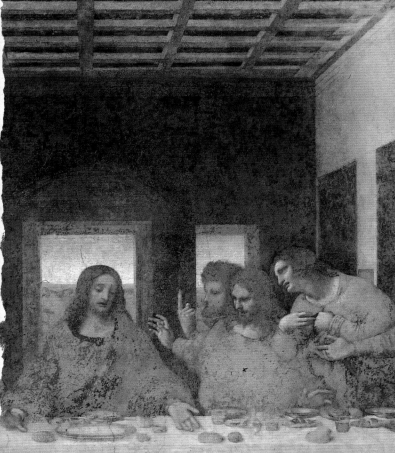

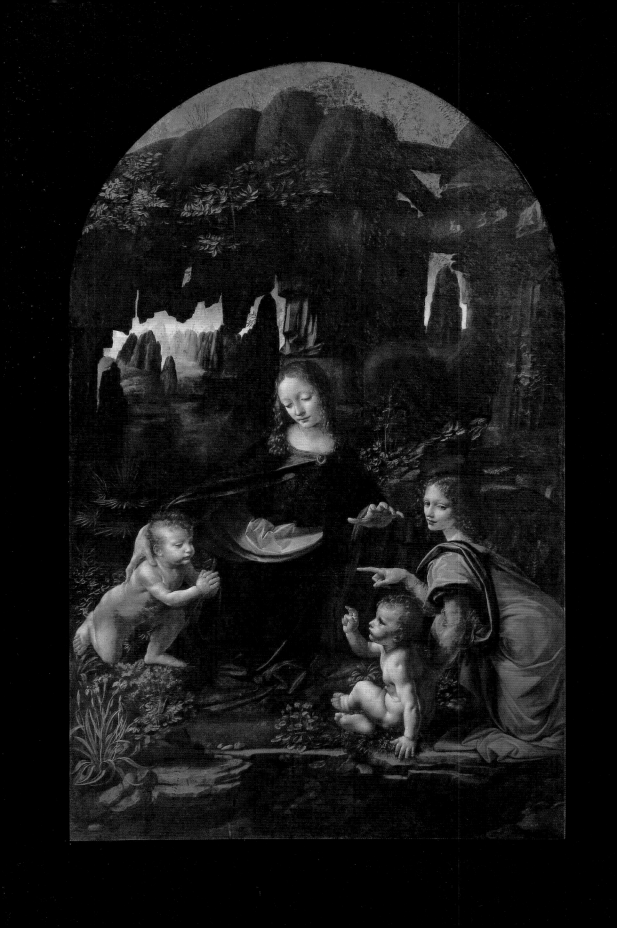

Alessandra
Fregolent

LEONARDO
the universal man

THUNDER BAY
P·R·E·S·S
San Diego, California

ART DIRECTOR
Giorgio Seppi

MANAGING EDITOR
Tatjana Pauli

DESIGN AND LAYOUTS
Elena Dal Maso

COVER
Federico Magi

MAP
Studio Margil, Pavia

ENGLISH TRANSLATION
Jay Hyams

TYPESETTING
Michael Shaw

 Thunder Bay Press
An imprint of the Advantage Publishers Group
THUNDER BAY 5880 Oberlin Drive, San Diego, CA 92121-4794
P · R · E · S · S www.thunderbaybooks.com

© 2002 Mondadori Electa S.p.A., Milan

English translation © 2004 Mondadori Electa S.p.A., Milan
All rights reserved

All notations of errors or omissions should be addressed to Thunder Bay Press, Editorial Department, at the
above address. All other correspondence (author inquiries, permissions) concerning the content of this book
should be addressed to Mondadori Electa S.p.A., via Trentacoste 7, Milan, Italy.

ISBN 1-59223-348-1

Library of Congress Cataloging-in-Publication Data available upon request.

Printed and bound in Spain by Artes Gráficas Toledo, SA
1 2 3 4 5 09 08 07 06 05

Contents

Preface

Perhaps without meaning to—or foreseeing it—Leonardo da Vinci has become a basic point of reference in the development of modern Western civilization. He was famous in his lifetime, when poets, intellectuals, and sovereigns spoke and wrote about him, perhaps requesting his presence or at least one of his paintings, and over the centuries his fame has only increased, bringing him to the borderland of myth. For those who study and have studied Leonardo—painter, sculptor, engineer, architect, inventor—the material is inexhaustible. The excellence of the tangible evidence and of the information in the objective historical documents makes it difficult to establish a "normal" measure by which to judge him. Paradoxically, some seek to diminish his role, reducing him to a precursor who merely "foresaw." This view disregards his enormous achievement in refashioning the patrimony of knowledge available first in Florence, the city of his training, then in Milan, where he spent many years, then in Rome, Venice, and the other cities he came in contact with or where he stayed during the course of a life that can be characterized as a true "intellectual adventure."

The distortion begins when people try to make him into a scientist in the modern sense. Leonardo began with experience, made use of the mathematical method to rationalize his observations, and then returned to experience to actively operate on nature using technology; the three steps he used are still central to modern science, but he used them in a different way. For him, painting represented the synthesis of all the sciences. According to that belief, it is the painter, not the scientist, who achieves the final awareness of the meaning of reality, and not simply in details or in what is mutable, but in the deepest sense of things. This aspiration explains his tireless research and continuous investigations, the works laid aside, the works returned to and reworked, the innumerable versions, and the elusive fascination of all his creations.

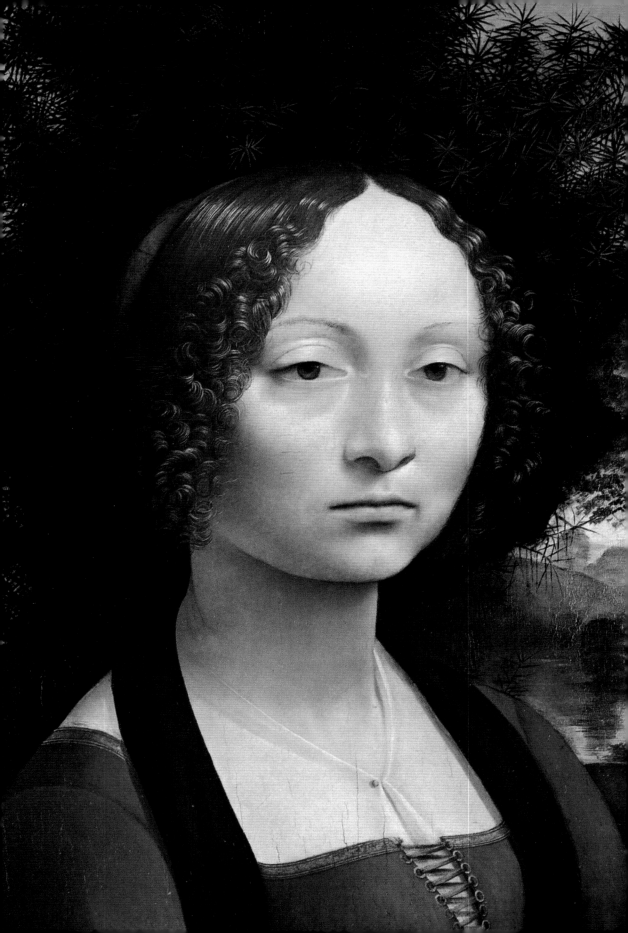

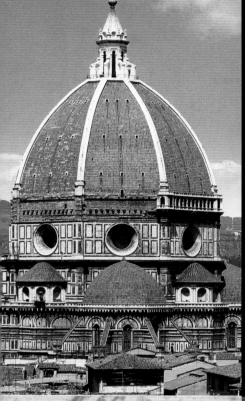

1452–1482
Florence,
the Cradle of
the Genius

*In the city of Lorenzo the Magnificent,
practice and theory constitute the premises
for the art of Leonardo.*

CHILDHOOD

Leonardo was born at Anchiano, near Vinci, on April 15, 1452, the natural son of Ser Piero, a well-to-do notary living in that Tuscan city, which is located about twenty miles from Florence. His mother, a peasant girl named Caterina, was of a lower social position than his father, and sometime after giving birth to Leonardo, she married Antonio del Vacca and lived on property owned by Ser Piero. She stayed in touch with her son, even visiting him in Milan many years later.

Leonardo was raised in the home of his grandfather, Antonio da Vinci. His father married four times but had his first legitimate heir only in 1476; he went on to father another eight boys and two girls. There was nothing unusual or unseemly about a child born out of wedlock, at least not when a family could afford to feed the extra mouth. Nor did the position imply disadvantages for the child. There is thus no reason to believe that Leonardo, who grew up in a middle-class household, did not receive affection or support from his parents, much

as the many illegitimate children in more illustrious families received affection and support. Such children could enter high positions in the church or the army and sometimes even inherited their father's title and holdings.

At the time of Leonardo's birth, Florence was a republic in which power was held by an oligarchy of powerful families, chief among them the Medici, a family of bankers that had recently acquired great wealth. Cosimo de' Medici, remembered as the "father of his country," had allied himself with the middle class and the working-class people of the minor guilds, and without subverting the republican institutions, he had ruled the government from 1434 to

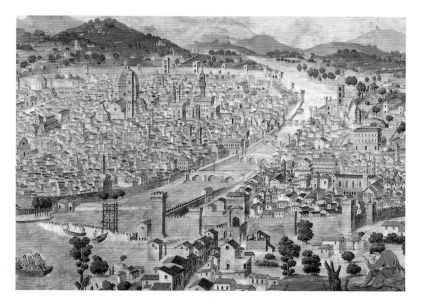

Opposite top: View of Vinci.

Opposite bottom: Benozzo Gozzoli, *The Journey of the Magi* (detail), 1459–62; Palazzo Medici-Riccardi, Florence. The ideal landscape in the background recalls the hills of Florence.

Left: Stefano Bonsignori, *View of Florence,* 1483; Museo Storico Topografico, Florence.

Below: Filippo Brunelleschi, dome of Santa Maria del Fiore, 1420–36; Florence.

1464 and made his position hereditary. Through his efforts and those of his son Piero, Florence became one of the leading cities in Italy and Europe, a center of business and commercial exchanges and the capital of the cultural revolution known to history as the Renaissance. None of the many states into which the Italian peninsula was then divided could challenge the supremacy of Florentine genius: not the kingdom of Naples, ruled by the Spanish house of Aragon; not the Papal States, the territory under the temporal rule of the popes, who in fact controlled much of central Italy; and not the duchy of Milan, ruled by the condottiere Francesco Sforza. The republic of Venice was concerned primarily with maintaining its control over the Mediterranean Sea, particularly following the 1453 conquest of Constantinople by the Turks. The other minor city-states in Italy, as well as the duchy of Savoy, the republic of Genoa, the territories of the Este family, and the republic of Siena, revolved around the five major states, which determined the geopolitical balance in Italy. In 1454 they had signed the Peace of Lodi, guaranteeing the peninsula almost

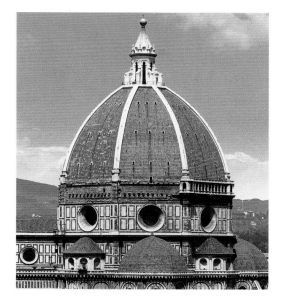

fifty years of uninterrupted peace.

In the middle of the fifteenth century, Florence went through a complex urban transformation. Within the medieval fabric many streets had been widened and straightened, squares had been enlarged, and new churches and impressive palaces built by the leading families, which also began constructing splendid villas on the surrounding hill-

sides. The impressive dome of Santa Maria del Fiore, erected by Filippo Brunelleschi between 1420 and 1436, dominated the architectural panorama, its broad volume emblematic of Florentine expansion and renewal.

Following the death of Piero de' Medici in 1469, control of the state went to his twenty-year-old son, Lorenzo. An astute politician, Lorenzo's main objective became the establishment of a balance of power among Italian states, with Florence, called the "new Athens" because of its cultural and artistic prestige, at the center. Palazzo Vecchio, headquarters of the government, the Signoria, became only the nominal seat of power, which instead had been transferred to the house built by Cosimo in Via Larga, the structure symbolic of the Medici dynasty, which housed a superb library and a magnificent collection of works of art (today the Palazzo Medici-Riccardi).

In the year of Piero de' Medici's death, Ser Piero da Vinci and his brother Francesco moved their families to Florence, where Piero's prosperous notary office involved him in important responsibilities in the public administration. It was presumably at this time that the young Leonardo moved to the city, destined to undertake a profession far different from that of his relatives.

IN VERROCCHIO'S WORKSHOP

An old anecdote, in truth lacking any confirmation, attributes to Ser Piero a decisive role in his son's future.

One of the peasants on his farm asked him to have a wooden shield painted in Florence. Instead of turning to a professional, Piero gave the shield to Leonardo, who painted a monster on it so truly fearsome that his father sold it for a high price and bought another shield to give the peasant. Faced with such a talented son, the far-sighted notary decided to find a spot for him in the workshop of Andrea del Verrocchio.

In his *Lives of the Artists,* Giorgio Vasari, the most important biographer of Italian artists from Cimabue to the artists of the mid-sixteenth century, states that the final buyer of the terrifying shield was none other than the duke of Milan, adding that when Piero showed Verrocchio some of Leonardo's drawings, the artist immediately took the boy into his workshop.

It would thus seem that Leonardo knew how to paint before becoming an apprentice of Verrocchio, his first and only real master. But Verrocchio transmitted to Leonardo a patrimony of techniques and

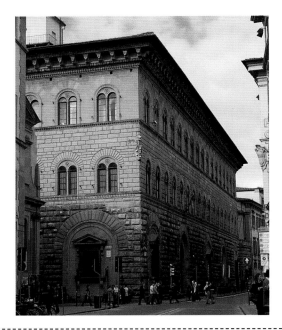

Left: Michelozzo, Palazzo Medici-Riccardi, 1444–59; Florence.

Above: Gold florin with lily, the coat of arms of Florence.

decorative standards and in exchange for established fees. In keeping with tradition, the director of the workshop took in and trained apprentices, their number varying according to the workshop's size and reputation. Such apprenticeship began at a very young age and ended with the attainment of full professional independence, confirmed by inscription in the guild of artists.

At the time of Leonardo's arrival, this system was going through a radical change. In the second half of the fifteenth century, in Medici Florence, the status and role of the artist began acquiring new meaning. Some artists began cultivating literary and theoretical interests and, not unlike poets and intellectuals, saw themselves as the bearers of a new culture. From its center at Florence, this new culture was spreading outward to Italy and Europe. This

theories fundamental to the arts; he taught Leonardo the knowledge consolidated by legions of painters, sculptors, and architects, among whom Verrocchio himself occupied a leading position.

Like the other Florentine workshops, superior in quantity and skill to those of any other city, Verrocchio's took on a wide variety of commissions, producing paintings, statues, jewelry, and valuable products in general, in keeping with the medieval custom according to which artists were like artisans, professional members of a guild held capable of satisfying various commissions and of guaranteeing the quality of execution of objects made in accordance with practical and

Above: Verrocchio, funerary monument of Giovanni and Piero de' Medici, ca. 1469–72; Sacrestia Vecchia, San Lorenzo, Florence.

Below: Sandro Botticelli, *Adoration of the Magi*, 1475; Uffizi, Florence. The crowd of onlookers includes members of the Medici family.

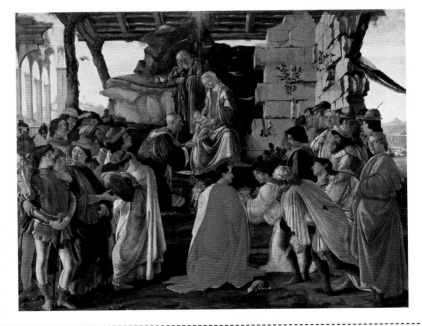

The Motions
of the Soul

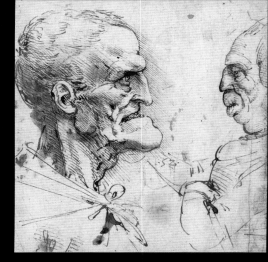

The centuries-old tradition according to which art imitates life was at the heart of the fifteenth-century pictorial representation on which Leonardo's training was based. Since painting "presents the works of nature to the senses with truth and certainty," to present the natural world it was necessary to understand the laws behind its functions, meaning the principles of physics and the modalities of vision, such as optics and perspective. Painting, however, goes far beyond mere imitation and becomes itself the creation of a universe that contains within itself the creative force of nature, a "spiritual virtue . . . infused in bodies, which through their natural use are retracted or bent, giving them active life of marvelous power."

In the same way, a portrait is far more than merely a faithful registration of physical features and anatomy, the study of a human body, and is an instrument making it possible to trace the mechanism that causes each emotion. The movement of muscles corresponds to the mobility of sentiments, variations in the state of mind are reflected in changes in features and gestures, leading to a variety of expressions and attitudes, including the gentle sweetness of the Madonna, the furious rage of the combatant, the sorrowful awe of the apostles.

"That figure whose attitude best expresses the passion that moves it is most worthy of praise." This phrase from Leonardo's *Treatise on Painting* summarizes a basic concept: painting must represent through exterior appearance the "motions of the soul," the sentiments, the psychology, of the person portrayed. This approach to portraiture did not begin with Leonardo. Before him, Leon Battista Alberti had called attention to the "motions of the soul," expressible in the "movements of the body," and the study of physiognomy—which consisted of the observation and classification of facial features that were then used to establish the character components (the

Above: Leonardo, *Two Grotesque Profiles*, ca. 1487–90; Royal Library, Windsor.

complexions) of each individual—was a discipline with a precise and widespread tradition.

While declaring his distrust of "false physiognomy and chiromancy," because they had "no scientific foundation," Leonardo aspired to express psychic states with the use of outward appearances and labored to imbue images with the "invisible," the spiritual energy by which art acquires a dimension beyond the merely "realistic," a dimension that is ineffable and divine. Several scholars have advanced the theory that Leonardo wrote a treatise on physiognomy, which is

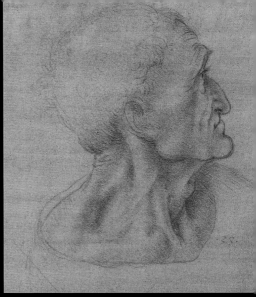

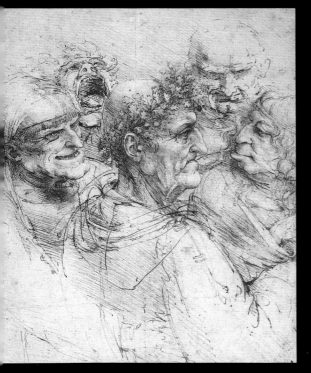

Above: Leonardo, *Head of Judas*, ca. 1495; Royal Library, Windsor.

Left: Leonardo, *Five Grotesque Heads*, ca. 1494; Royal Library, Windsor.

Below: Leonardo, *Head of Philip*, ca. 1495; Royal Library, Windsor. Only three of Leonardo's sketches and preparatory drawings refer to *The Last Supper:* the heads of Philip, Judas, and St. James the Greater.

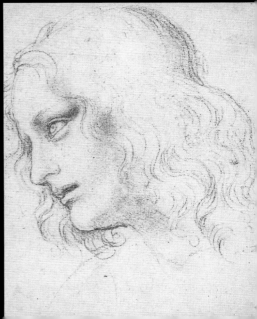

today lost but that circulated widely, such that echoes of it appear in treatises on similar subjects written at the same time and later. Even in the absence of such a work, Leonardo's drawings and paintings explain his enormous, capital importance in terms of modern portraiture, in which exterior manifestations become expressions of the inner state.

involved a new concept of the world that took in every aspect of human activity, including art. From this concept would be derived the figure of the "universal man," eventually personified by Leonardo.

In the hope of assuring him a brilliant future and also making him a gentleman, Ser Piero let his son enter a profession that was acquiring a new status. Assimilating the culture, ideals, and lifestyle of the humanists, artists were breaking free of the limited space of the workshop and opening themselves to the world of letters and theoretical reasoning.

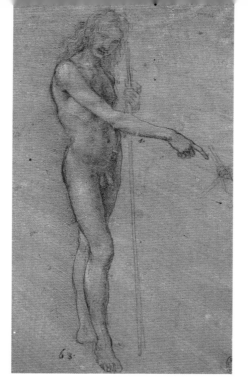

Above: Leonardo, *St. John the Baptist*, 1475–78; Royal Library, Windsor.

This spirit had begun with Filippo Brunelleschi and Masaccio, the founders of perspective, who had magnificently opened the way for the movement of rebirth in the arts in the first half of the century. Eminently literary in terms of its aspirations and its very nature, the movement had spread among architects, painters, and sculptors, many of whom, like Leonardo later on, made use of the written word to express principles and to present knowledge gleaned from artistic practices.

Although Verrocchio was by no means a literary artist, in the practice of his profession he proved himself both a skilled interpreter of the new artistic movement and an admirer of the antiquity that the humanists sought to bring back to life. Perspective and anatomy were taught in his workshop, the latter based on copying plaster casts of

bodies, partial and entire, but more important was his fusion of the liberal and the mechanical arts, theory and practice, an approach that would later be at the base of Leonardo's creativity.

THE MEDICI AND THE PLATONIC ACADEMY

Verrocchio's workshop was one of those favored by the leading patrons of the city, the Medici family, also patrons of the Platonic

Verrocchio, *Putto with Dolphin*, ca. 1478; Palazzo Vecchio, Florence.

Above: Giorgio Vasari,
*Lorenzo the Magnificent among
the Scholars and Philosophers of His
Court,* 1559; Palazzo Vecchio, Florence.

Below: Ghirlandaio,
Confirmation of the Rule
(detail with Poliziano), 1485;
Santa Trinita, Florence.

Academy, a circle of intellectuals, scholars, and artists united by common cultural interests. The academy's headquarters was the Medici villa of Careggi, and its tutelary deity was Marsilio Ficino, who had translated many texts of Plato and of the Neoplatonic tradition into Latin and had established the doctrine that provided the philosophical basis for the new role of man, which eventually influenced every field of knowledge.

Ficino's abstract, metaphysical speculations were to have important repercussions on the art of the time, inspiring and informing, for example, much of the poetry written by Angelo Poliziano and many of the paintings by Sandro Botticelli, both of whom were leading members of the "gang" that formed around Lorenzo the Magnificent.

Leonardo's interest in numbers, calculations, and mathematical ratios cannot be directly attributed to the Platonic Academy, for any influence the Laurentian circle had on him was not a matter of shared ideas, theories, and aspirations but rather a result of his absorbing the general cultural atmosphere. Leonardo had no more than a primary education, and despite his innate and inexhaustible desire for knowledge, he did not possess the necessary learning to follow the scholars' esoteric debates. That world was closed to him, as it was to everyone who did not know Latin. Leonardo made futile attempts to make up for this, as it prevented him from reading the texts of both ancient and contemporary authors. Such works were written for an exclusive, educated section of the population. To satisfy his thirst for knowl-

grammar. Upon that base, as a self-taught man, he steadily built up his knowledge. Later in life he would describe himself—proudly reaffirming his independent way of thinking and the value he put on experience—a "man without letters." His learning began with his contact with artisans and their techniques, and later, perhaps even more important than any books, his thinking was formed by his encounters and discussions with scientists, men of letters, and philosophers, creating an indissoluble bond between experience and study. For Ficino and the Neoplatonists, knowledge was reached by way of a mystical ascent toward the divine; for Leonardo nothing could be known for certain that could not be confirmed by experience.

edge, Leonardo had to turn to indirect sources, to vernacular translations of those works, for his understanding of Latin never rose above an elementary level.

His artistic, intellectual, and sentimental education came from the far more concrete atmosphere of the workshops, the days spent among the masters and the apprentices. Because of his father's financial standing, Leonardo enjoyed certain advantages and had received a basic level of education, primarily concerning the use of the abacus and the rudiments of

During these first years in Florence, Leonardo's friendships and acquaintances were formed between the walls of the workshop and at the workplaces of Verrocchio in a city given to celebrating the fleeting pleasures of youth (a few years later Lorenzo the Magnificent was to write a poem on the subject). Chivalric combats and contests, jousts, triumphal parades, and costumed processions inspired by mythology were all enormously popular with the Florentines and involved contributions from most

Leonardo

If you scorn painting, which is the sole imitator of all the manifest works of nature, you will certainly be scorning a subtle invention, which with philosophical and subtle speculation considers all manner of forms: sea and land, plants, animals, grasses, flowers, all of which are enveloped in light and shade; truly this is science and the legitimate daughter of nature. (Codex A)

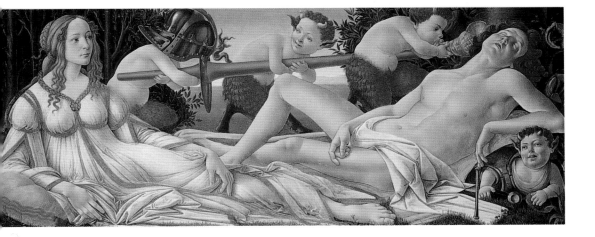

of the great artists of the period, charged with the creation of every detail, from costumes to stage settings. The city's streets and squares were the settings for tournaments, processions of horsemen, street performances, and singing, large-scale events in which all citizens participated, whether as performers or spectators.

The two eldest sons of the city's leading family were no exception. In 1469, Lorenzo's wedding was celebrated with a joust in Piazza Santa Croce. A few years later, in 1475, his younger brother Giuliano competed in a similar joust, bearing a standard dedicated to the "Peerless," the beautiful Simonetta Vespucci. Poliziano celebrated Giuliano's victory in his *Stanze per la Giostra di Giuliano de' Medici*, giving the romantic event a mythological and symbolic dimension. Botticelli portrayed the two lovers as Venus and Mars and used Simonetta as the model for many of his female figures. The woman dearest to Lorenzo, to whom he dedicated many love poems, was Lucrezia Donati, traditionally identified as the *Lady with a Bunch of Flowers* sculpted by Andrea Verrocchio.

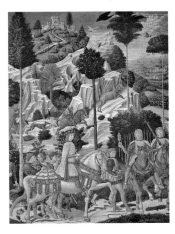

Verrocchio was often called on to create devices and decorations for the Medici jousts and for various public ceremonies, such as Galeazzo Maria Sforza's entry into Florence in 1471, and in such cases made use of his young assistants.

Leonardo was only one of them; working alongside him were Lorenzo di Credi, Botticelli, and Pietro Perugino. Together they constituted the propulsive force of Florentine art and were a flower in the buttonhole of Lorenzo de' Medici, who for the time being kept them in their homeland, where they could impress visitors and ambassadors; he was later to make use of them to promote the glory of Florence and the Medici throughout Italy.

Opposite top: Maso Finiguerra (attrib.), *Mercury and the Arts in Florence*, ca. 1460; British Museum, London.

Opposite bottom: Ghirlandaio, *Miracle of St. Francis* (detail with view of Florence), ca. 1485; Santa Trinita, Florence.

Top: Sandro Botticelli, *Venus and Mars*, ca. 1483; National Gallery, London.

Above: Benozzo Gozzoli, *The Journey of the Magi* (detail with the young Lorenzo de' Medici on horseback), 1459–62; Palazzo Medici-Riccardi, Florence.

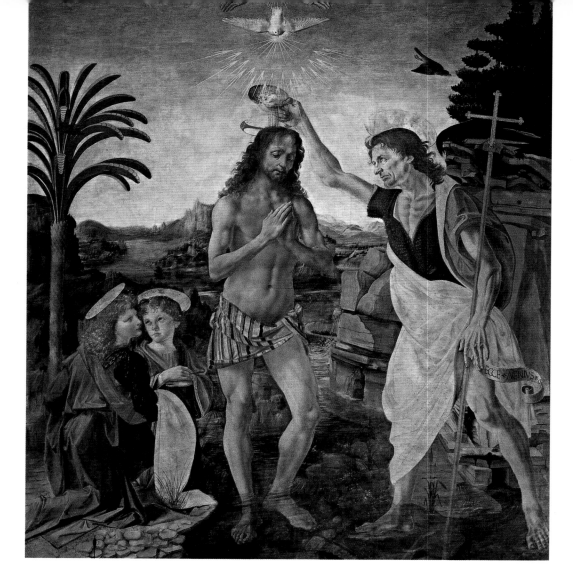

In 1472, at age twenty, Leonardo was no longer a promising apprentice, for by then he figured among the members of the Company of St. Luke, the painters' guild of Florence. His membership in the guild confirmed his status as an independent master, but his close association with Verrocchio continued, as is indicated by his involvement in works commissioned from Verrocchio.

There is the *Baptism of Christ,* a panel dated to around 1475 that Verrocchio, as was his habit, entrusted to a team, in this case including Leonardo, who made the background landscape and the angel

in the foreground to the left. The figure of the adolescent angel with its ineffable sweetness gave life to a legend, repeated by Giorgio Vasari, according to which Verrocchio, seeing "that the young Leonardo had shown himself to be a better craftsman," resolved that he would never take up a brush again.

Anecdotes about students outdoing their masters abound—they are a common element of art-history literature—but this example may involve an element of truth in that it reflects a change that occurred in Verrocchio's career. Increasingly occupied as a sculptor, he left more and more of the paint-

ing to his disciple, Leonardo. The change involved the terms of their relationship: no longer master and student, they were now equals, both colleagues and friends.

That Leonardo was living with Verrocchio at least until 1476 is indicated by a document in which he is cited as "Lionardo di Ser Piero da Vinci, staying with Andrea del Verrocchio"; the document relates to his involvement, together with other youths, in an anonymous denunciation for sodomy, a charge of which he was acquitted.

THE BEGINNING

Leonardo's earliest works have been determined on the basis of a few historically objective documents. Among the sources closest to him chronologically, the most important in terms of wealth of information are the so-called Anonimo Gaddiano and Giorgio Vasari. What such sources hand down to

Opposite: Andrea del Verrocchio and workshop, *Baptism of Christ,* ca. 1475–78; Uffizi, Florence. Leonardo made the kneeling angel to the left and the landscape; Sandro Botticelli made the angel to the right.

Right: Luca Signorelli, *Adoration of the Magi* (detail showing men's dress of the late fifteenth century); Uffizi, Florence.

Below: Leonardo, *Profiles and Faces,* ca. 1478; Royal Library, Windsor.

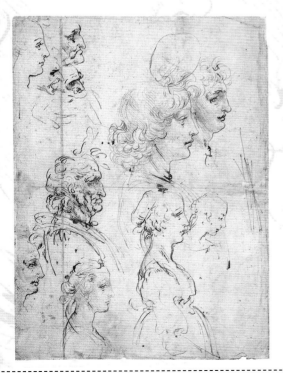

us—in invariably laudatory terms—is the image of a person full of grace and fascination, an artist gifted with exceptional talent that he applied from the very beginning of his career to precise images of the human figure and nature. The works that are believed to date to his first period in Florence confirm this.

There are only a few such works, and they are omitted from Leonardo's catalog, which is small, for so many works have been lost or are contested or negated: only four paintings are unquestionably attributed to him. The paintings, along with the drawings attributable to this period, reveal that Leonardo was closely following the style of his teacher, almost imitating him. Verrocchio taught him to study anatomy and the proportions of the human body, and from him Leonardo inherited typologies of intensely expressive faces, flowing poses, graceful gestures; he also took details and decorative motifs that reveal an attraction to a fluid, multicolored vegetal microcosm composed of volutes, spirals, interlaced forms, tiny details that are chiseled and crystalline or vibrant and mobile, sharply outlined details that have the same stylis-

tic perfection and imprint of the goldsmith found in Verrocchio's sculptures. The power of Verrocchio's style was to show up decades later in many works by Leonardo.

Leonardo's most characteristic interest—the observation and presentation of natural reality—appears in what is considered his first dated graphic work, a landscape to which he added, writing in an elegant calligraphic hand and using the mirror writing that would distinguish his later writing, the date, August 5, 1473, and that it was the feast day of the Madonna of the Snow. This *Landscape with the Arno Valley* has been identified as a view from the hills of Florence, but Leonardo may have made it while visiting the area of his birth. Those hills and valleys, wrapped in an atmosphere that makes them seem evanescent, may have provided the first of his many studies of the natural world.

Landscapes, with their infinite variations, had enormous appeal to Leonardo all his life. He spent most of his time in urban settings, in the most important cities and places of his period, and only rarely as a mere observer: because of the fascination of his character and, most of all, the power of his intellectual gifts, he was called on to be creative in the service of the most outstanding figures of his day. But all the while he never ceased to seek solitude in the country. Only far from worldly concerns could he enter into contact with nature, which he always sought to investigate, convinced as he was that "those who take as their authority any other than nature, mistress of the masters, labor in vain" (Codex Atlanticus). His goal as an artist was to draw on the creative spirit of nature, and it was from nature, understood as a problem to solve, a mystery to

Below: Leonardo, *Landscape with the Arno Valley* (detail), 1473; Uffizi, Florence.

Opposite: Leonardo, *Annunciation*, 1475; Uffizi, Florence

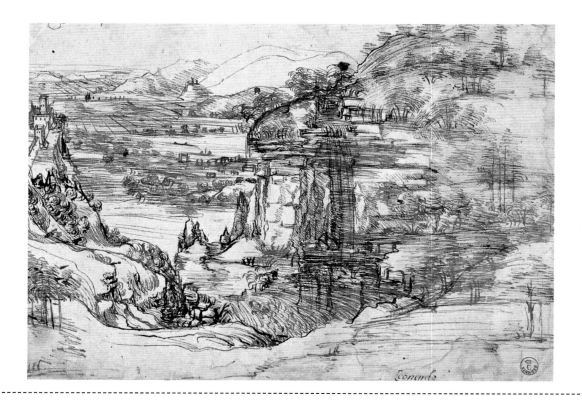

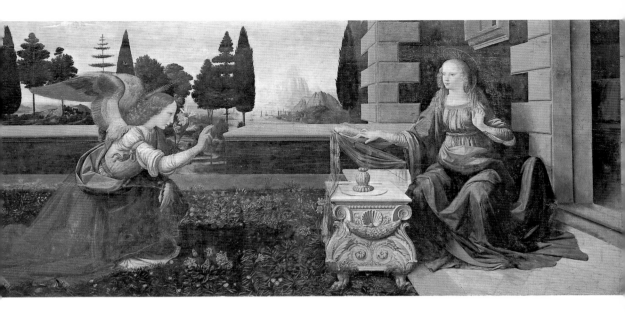

unravel, that he drew the inspiration for his later endeavors as a scientist. To Leonardo, being a man of science meant analyzing the causes and effects of the natural world so as to be able to re-create them in his works as a painter and sculptor.

The essential tool in the study of nature was the drawing. Far more than the written word, the graphic medium let him record the infinite variety of the natural world, beginning with the variations of light that give things shape and color and the sense of movement that is inherent in all things. In this landscape of 1473—in which one senses the atmosphere of a hot summer day, with the scorching heat obscuring the view, making outlines hazy and bodies vibrate—as in the countless other pages left by Leonardo, with studies of plants

Leonardo

When the sun rises and drives away the mists, and the hills begin to grow distinct on the side from which the mists are departing, they become blue and seem to put forth smoke in the direction of the mists that are flying away.

(Codex Arundel)

and animals, faces, anatomy, machines, instruments, and so forth, it is clear that there is no divide between Leonardo the researcher and Leonardo the artist. With the passage of years his subjects become more specific, his drawings grow increasingly complicated and are more obviously related to actual projects. What also increases is his ability to explain his experiences to himself and to others in writing; but this early landscape is emblematic of his need to explore reality through direct observation and to grasp it by means of a drawing.

FIRST WORKS

Among the first works Leonardo made alone, dating to 1475, is *The Annunciation*, long believed to be by Domenico Ghirlandaio, a Florentine painter whose religious scenes crowded with portraits of prominent Florentine personalities are in Florence's main churches. This panel, originally in the Monte Oliveto monastery near Florence and today in the Uffizi, is still immature in terms of its handling of perspective—there is the incongruous position of

the Virgin's right arm and the right side of the composition—but the lily carried by the angel, the field woven of flowers on which he kneels, and the row of trees in the background speak of an artist enamored of nature. Leonardo reveals his great talent in the special grace and mystery he confers on this traditional subject. The botanical details and the crystalline quality of the light reveal that he was paying close attention to the Flemish paintings that were then beginning to make their way into Florentine collections, including those of the Medici.

Flemish artists were also the source of the painting technique Leonardo employed, for it was the Flemish who spread the use of oils, a binder that conferred greater brilliance on painted surfaces, permitting new chromatic experiments and giving

increased depth to shadows and greater luminosity to light. Around 1474, fully exploiting the expressive possibilities of the medium, making use of a mixture of tempera and oil, Leonardo made the portrait of Ginevra de' Benci, today in the National Gallery of Art, Washington, D.C., the first of a series of female faces that contributed to making him one of the portraitists most sought after by women of the period.

Two panels depicting the Virgin and Child date to the early 1470s; one is in Munich, the other in Washington, D.C. Leonardo further developed the Virgin and Child motif during that decade in drawings and other paintings (the attribution of the paintings is disputed). An autograph note of 1478 indicates that he had begun work on "two figures of Our Lady," one of which could be the *Benois Madonna* in the Hermitage. It is unclear what led him to repeat the subject and whether he did so as a result of pressure from patrons. What is certain is that Leonardo succeeded in establishing a new, highly personal relationship between the Virgin and Child, one charged with intense emotions, a prelude to his later religious works.

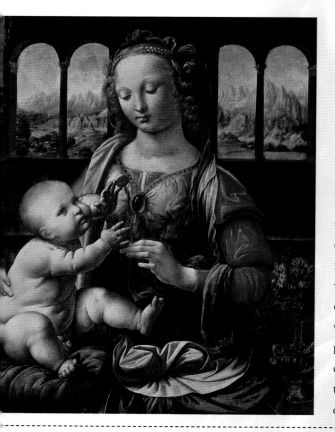

Small-size panels depicting the Virgin and Child were usually made for private devotion and did not constitute, from the financial point of view, an advantageous commission. Leonardo was offered a far more promising and public commission—and this time well documented—on January 10, 1478:

Leonardo

It is my intention first to cite experience, then to demonstrate through reasoning why experience must operate in a given way. This is the true rule that must be followed by all those who investigate natural processes.

(Codex E)

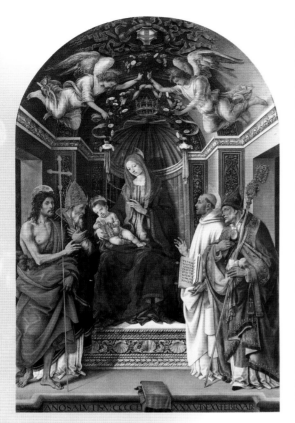

government. Some enemies were internal, the families traditionally hostile to the Medici; others were external, including the pope, the king of Naples, and the republic of Siena. At the urging of Pope Sixtus IV, the conspirators planned to murder both brothers during the celebration of Mass in Santa Maria del Fiore. Giuliano was killed, stabbed eighteen times; Lorenzo, only slightly wounded, escaped and was acclaimed by the crowd. The guilty and those suspected of having assisted in the plot were treated severely. The murderer of Giuliano, Bernardo Bandini Baroncelli, executed in 1479, appears in a famous macabre drawing (Musée Bonnat, Bayonne) that some attribute to Leonardo.

Opposite: Leonardo, *Madonna and Child (Madonna of the Carnation)*, ca. 1470; Alte Pinakothek, Munich.

Left: Filippino Lippi, St. Bernard altarpiece, 1485; Uffizi, Florence.

Below: Leonardo, *Benois Madonna*, 1475–78; Hermitage, St. Petersburg.

an altarpiece for the St. Bernard Chapel in Palazzo Vecchio, later entrusted to Domenico Ghirlandaio and finally to Filippino Lippi, who completed it seven years later. Why or by whom Leonardo's involvement was canceled is unknown, but on March 16 the Signoria paid him an advance of twenty-five florins. Regardless of the circumstances, this was not to be the last time in which Leonardo abandoned a job. Driven by his restlessness and curiosity or by the appeal of new projects, or impeded by some unknown force, Leonardo often abandoned a project to take off on something new.

During that very year, 1478, the future of the Signoria seemed threatened: April 26, 1478, was the day of the "Pazzi conspiracy." Enemies had been plotting against the Medici brothers Lorenzo and Giuliano, the latter only nominally involved in the

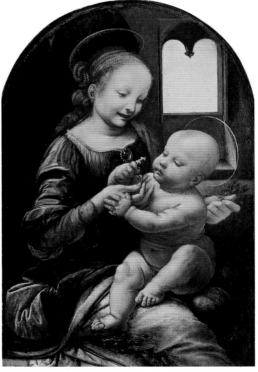

The portrait of Ginevra de' Benci—a panel (15 x 14¼ in.) today in the National Gallery of Art, Washington, D.C.—is considered the first individual portrait made by Leonardo, the first example of a genre in which he would give proof of absolute excellence, destined to influence the production of his and future gener-

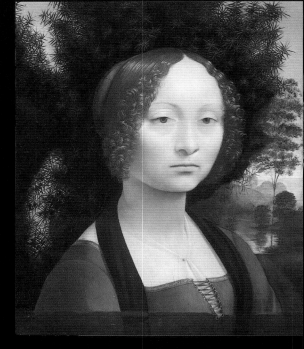

ations of painters, both in Italy and the rest of the world. The "psychological portrait" is still at an embryonic stage in this work, yet this passive female face is a prelude to the enigmatic expressions full of emotions, evocative of the secret spirit that pervades humans and nature, that Leonardo made in later years.

The young woman, positioned three-quarters against a landscape background dominated by a large juniper bush, has been identified as Ginevra de' Benci, cited by various sixteenth-century sources as the model for a painting by Leonardo. The bush behind her thus makes a metaphoric reference to her name (juniper is *ginepro* in Italian), as does the sprig of juniper framed by a branch of laurel and a palm frond that appears on the back of the painting, together with a cartouche bearing the motto *Virtutem forma decorat* ("Beauty adorns

virtue'). The bottom part of the panel is missing. This section may have constituted one third of its original height and included the woman's hands, perhaps arranged in a gesture similar to that of a silverpoint drawing preserved at Windsor. This gesture was inspired by that of *Lady with a Bunch of Flowers,* a marble bust by Verrocchio, whose influence also appears in the careful rendering of details and in the meticulous pictorial execution, which gives the woman's skin its glow and makes the details of her dress and the plants palpable. The rigid but stately presentation of the young woman, along with the luminous gleams that emphasize the ringlets of her hair, recalls Flemish works, which Leonardo would have seen and assimilated during his years of apprenticeship. His experiments with technique, a legacy of his artisan training, drove him to work the pictorial surface with his fingers to increase the mimetic effect of the skin, an expedient later adopted in the *Mona Lisa* and also derived from northern European examples.

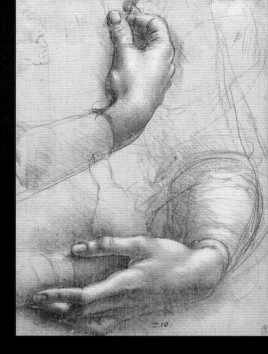

Opposite: Leonardo, portrait of Ginevra de' Benci, ca. 1474; National Gallery, Washington, D.C.

Right: Verrocchio, *Lady with a Bunch of Flowers,* ca. 1478; Bargello, Florence.

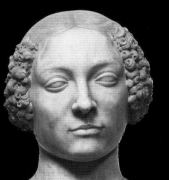

The occasion that presumably led to the execution of the painting and that furnishes a further aid to its dating, which is otherwise deduced from the stylistic evidence, was the marriage of Ginevra de' Benci, seventeen years old, to Luigi Niccolini, on January 15, 1474. The inscription cited above, reinforced by the fact that juniper was symbolic of chastity, seems eminently well suited to a young bride.

The virtuous Ginevra, a poet herself and the inspiration of two sonnets by Lorenzo de' Medici, was celebrated in a series of poetic compositions from the Medici circle, which refer to the love for her of Bernardo Bembo, the Venetian ambassador to Florence. This has suggested a different, enticing, but improbable theory concerning who commissioned the painting.

Top: Leonardo, *Study of Hands,* ca. 1475–76; Royal Library, Windsor.

Lorenzo de' Medici, Known as "the Magnificent"

(Florence, 1449–1492)

When Lorenzo was born, the first child of Piero de' Medici and Lucrezia Tornabuoni, the Medici dynasty, founded by his grandfather Cosimo, had been ruling Florentine public life for more than thirty years as the leaders of the city's oligarchic government.

In 1464 Cosimo was succeeded by Piero de' Medici, who died five years later; Lorenzo was already prepared to complete the work of concentrating the family's power. His education was princely, his teachers including the leading humanists of the time, John Argyropoulos, Marsilio Ficino, and Cristoforo Landino, and he himself was an accomplished man of letters, most of all as a poet.

When he took over the rule of Florence, and thus was absorbed by affairs of state, his active participation in the city's cultural life diminished, but he took care to increase its prestige, involving himself in the university of Pisa, the organization of the future Laurentian Library, and the promotion of the vernacular poetic tradition, as well as acting as a patron of the arts and letters.

He was firm in his handling of internal and external struggles and in his dealings with the continuous changes in alliance among the Italian states. Following the Pazzi conspiracy, in which his brother Giuliano lost his life, and after the interdict of Florence in response to the revenge taken by the Medici, Lorenzo sought to break the encirclement and isolation of Florence by the audacious move of going to Naples to con-vince King Ferrante to break with the anti-Florentine league formed by Pope Sixtus IV. To gain the support of the church and to help the ecclesiastic career of his son Giovanni, later to be Pope Leo X, he assisted Vatican financing through the Medici bank.

In the last years of his life he gradually distanced himself from the Milan of Ludovico Sforza, inclined toward an alliance with France, and at his death the balance he had struggled so hard to maintain seemed irremediably compromised.

Verrocchio, bust of
Lorenzo de' Medici,
National Gallery,
Washington, D.C.

The failed coup d'etat resulted in an increase in Lorenzo's authority, but it was also the first indication that the balance of power established by the Peace of Lodi was beginning to totter. It was still a brilliant period for the city of Florence, thanks to Lorenzo, who succeeded in maintaining stability and was considered one of the most influential rulers on the Italian peninsula, but the sunset of this bright time was fast approaching.

THE LAST FLORENTINE WORKS

It seems probable that around 1480, by which time Leonardo was almost thirty, he worked as a sculp-tor on the rearrangement of the Garden of San Marco, an oasis of peace and beauty built by Lorenzo where ancient works in marble were stored. No youthful works of sculpture by Leonardo are known, but doubtless he was trained in sculpture in the same manner and during the same period in which he learned painting, meaning alongside Verrocchio, who in that same period was busy on some of his greatest works. When, a few years later, Leonardo claimed to be an expert sculptor, he undoubtedly did so on the basis of concrete experience despite the fact that no traces of such works from his first Florentine period are known.

Leonardo's activity as a sculptor later involved him in the design for a statue that was never made: the equestrian statue of Francesco Sforza. Once again, the example of Verrocchio, who in the early 1480s set off for Venice to make an equestrian statue of Bartolomeo Colleoni, was of great help to him.

After man, the horse is the living creature that most stimulated Leonardo's creativity. The first work that offered him the chance to depict horses was the large panel that can be seen as the culmination of the first phase of his career, *Adoration of the*

Top: Leonardo, *Adoration of the Magi* (detail), 1481–82; Uffizi, Florence.

Right: Leonardo, drawing of horses and animals related to *Adoration of the Magi*, ca. 1480; Royal Library, Windsor. The creation of the *Adoration* was preceded by a great deal of preparation, as indicated by numerous drawings, some of which are quite different from the layout of the final scene and the figures that fill it.

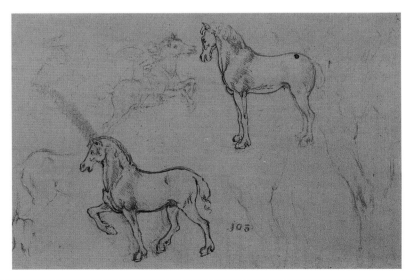

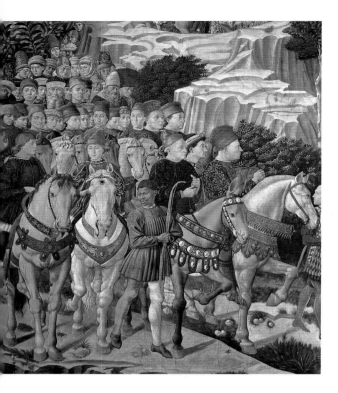

1462, the parading horsemen include Lorenzo and other leading members of the Medici family, which in fact promoted and participated in the company.

Leonardo's version of the sacred event was completely new and had an enormous impact on everyone who had a chance to see the panel, which was left stored in the home of Amerigo Benci, father of Ginevra, when Leonardo moved from Florence to Milan. The work entered the Medici collection and has remained in Florence, today in the Uffizi Gallery.

Also unfinished, and without any contemporary references or documentation concerning its origin, is *St. Jerome* in the Pinacoteca Vaticana. Even so, along with *Adoration of the Magi, The Last Supper,* and *Mona Lisa,* it is one of the four paintings that have always been unanimously attributed to Leonardo. The saint is presented in the solitude of a rocky landscape in the act of striking his chest with a stone, a lion as his only companion. The partial state of execution detracts nothing from the power of the figure, his skin-and-bones body reproduced perfectly against the monochromatic layer of the preparation. His hollow cheeks, face furrowed by dark lines, and emaciated body give him the sense of a phantasmagorical apparition.

If, as some believe, this painting was among the works Leonardo mentioned in his list of things to bring to Milan ("certain figures of St. Jerome"), then it was made before 1482, the year of his departure; there are also hypotheses in favor of a later date, supported most of all by comparison with the works Leonardo produced in Lombardy.

Just as Leonardo set off northward, Florence, once the epicenter of the artistic rebirth, emptied of its leading artists.

This dispersion had been going on for a few decades and had been responsible for the formation of new schools: a primary example is the effect

Magi, left unfinished and never delivered to the monks of San Donato a Scopeto, who had commissioned the work from him in March 1481, stipulating that he complete it within twenty-four or at the most thirty months. The panel that finally decorated the main altar of San Donato was made in 1496 by Filippino Lippi. Oddly, in making his own version Leonardo had drawn on a similar subject painted by Filippo Lippi, Filippino's father.

The Epiphany was a particularly popular theme in Florence, since the arrival of the Magi and the baptism of Christ both occurred on January 6. As St. John the Baptist was the city's patron saint, this coincidence had special significance, and to properly celebrate it, the Company of the Magi organized a spectacular mounted procession, immortalized in the magnificent corteges of many Renaissance Adorations. In the version frescoed by Benozzo Gozzoli in Palazzo Medici from 1459 to

of Donatello on northeastern Italy. During the penultimate decade of the century, the list grew progressively longer. The architect Giuliano da Maiano left for Naples, followed by his colleagues Luca Fancelli and Giuliano da Sangallo; summoned to fresco the Sistine Chapel, Sandro Botticelli, Domenico Ghirlandaio, and Cosimo Rosselli took off for Rome, as did the sculptor Antonio del Pollaiuolo. Andrea del Verrocchio went to Venice and died there in 1488.

This diaspora of artists was part of the political designs of Lorenzo the Magnificent. Averse to the use of war as an instrument of power, he preferred subtler means of diplomacy, including using artists as ambassadors, sending them off to remind other rulers, whether enemies or allies, that Florence was still the cultural capital of Italy.

According to period sources, Lorenzo was behind Leonardo's move to Milan, inducing him to go to Ludovico Sforza as an artistic representative, accompanied by his fame as a musician and bringing with him a silver lyre in the shape of a horse's skull. He arrived in Milan with excellent credentials and soon found himself called on to put them to the test.

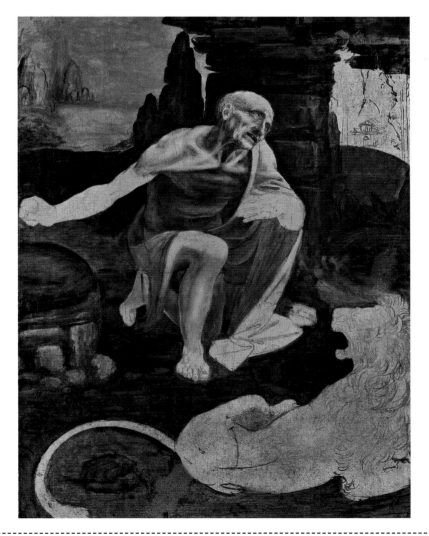

Opposite: Benozzo Gozzoli, *The Journey of the Magi* (detail with Piero and Cosimo de' Medici), 1459–62; Palazzo Medici-Riccardi, Florence.

Right: Leonardo, *St. Jerome*, ca. 1480; Pinacoteca Vaticana, Rome. According to tradition, this painting had a singular and complicated fate. Following the breakup of the panel, literally sawn in two in the late eighteenth century, all trace of it was lost until the lower portion was found in a Roman junk shop, where it was being used to cover a box. The upper portion had been made into a stool used by a shoemaker. The person who spotted the two pieces and reassembled the work was Joseph Cardinal Fesch, uncle of Napoleon and an avid collector. In 1854 the cardinal's heirs sold the painting to Pope Pius IX, and *St. Jerome* was placed in the Vatican Museums.

Adoration of the Magi

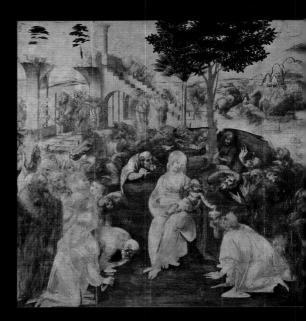

Adoration of the Magi is a large panel (94¾ x 95 in.) that entered the Galleria Medicea (Uffizi) in 1670, but its value as an absolute masterpiece was not immediately understood, and it was attributed to Leonardo dubiously on the basis of uncertain tradition. Relegated to the town of Castello and perhaps kept tucked away in a warehouse until 1794, the painting, damaged by neglect, underwent restoration early in the twentieth century that averted the danger of further loss of color, which had compromised its already poor legibility. Vasari's claim that Leonardo had begun *Adoration* only to leave it unfinished on his departure for Milan was confirmed by late-nineteenth-century research that made possible the precise attribution and dating of the work.

In March 1481 the monks of San Donato a Scopeta engaged Leonardo to complete the altarpiece within thirty months, but it was never completed, much less delivered, and remained stored in the home of Amerigo Benci, where Florentine artists saw it and were influenced by it. Its overall complexity, based on numerous preparatory drawings, implies an enormous amount of effort, such that *Adoration* is considered such an excellent painting that it can be taken as a summary of all Leonardo's research up to that time. Even the technique, although limited to the application of layers of bister and glaze, with minimal vari-

Top: Leonardo,
Adoration of the Magi,
1481–82; Uffizi, Florence.

tions in tone, cannot be considered a preparatory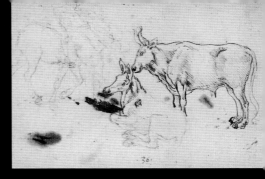
state, but assumes its own autonomous significance
and expressive value. The Virgin and Child located at
the center of a semicircle becomes the source for a
series of reactions amplified outward to the edges
of the composition, a prelude to the layout of *The
Last Supper*. The horsemen that battle in the back-
ground are part of the cortege of the Magi, among
whom, according to the apocryphal Gospels, a dis-
pute had arisen concerning who had found the Child
announced by the star. The figures studying the sky
remind us that the Magi were astrologers. The paint-
ing takes Florentine traditions to their extreme
consequences: in it can be seen the influence of
Masaccio, Ghiberti, and Donatello, invigorated by the
Neoplatonic culture of the Laurentian circle, in which
knowledge of the classics had a preponderant role.
The rhythm and volume of the figures is reminiscent
of an archaeological collection, such as the medal-
ions, incised gems, and cameos of the Florentine
collections, particularly those of the Medici. The
tumultuous rush that pervades the whole is con-
trolled by a strict perspective orchestration, worked
out in preparatory drawings that reveal a creative

process both impetuous and at the same time med-
itative. The historical presentation of a miraculous
event, the Epiphany of the Savior, with the awe and
joy it awakened, are rendered by the dramatic ani-
mation of the figures that surround the Child and
the accentuated chiaroscuro that makes their bod-
ies stand out.

Top: Leonardo, *Studies
of Donkeys and Oxen,*
ca. 1480; Royal Library,
Windsor.

Below: Leonardo, *Study
for the Adoration of the
Magi,* ca. 1480; Uffizi,
Florence.

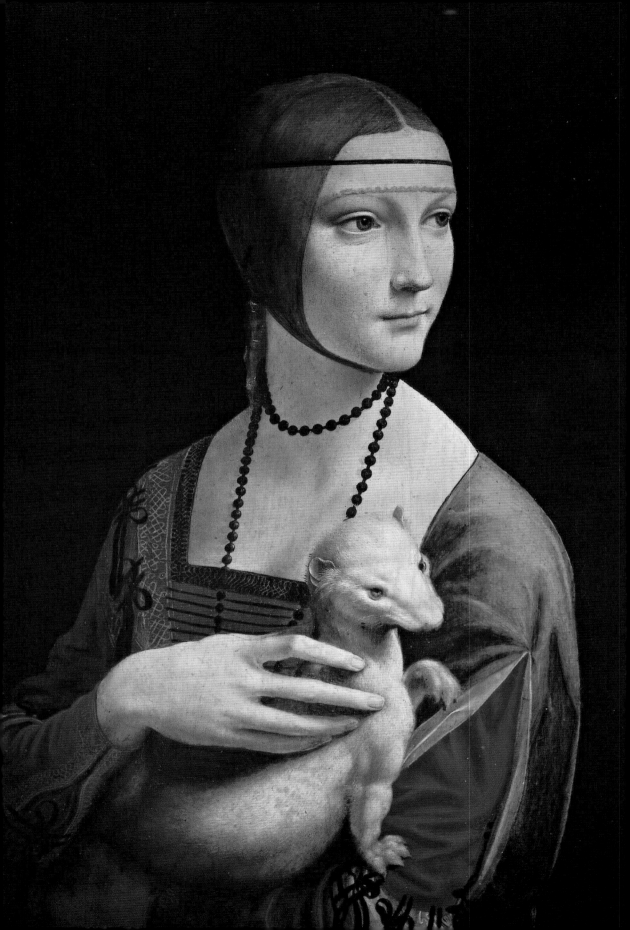

1482–1499
Milan, the Years of Maturation

Leonardo's arrival at the court
of Ludovico Sforza turns Milan
into a Renaissance capital.

THE SFORZA DUCHY

On his arrival in Lombardy, Leonardo was welcomed by one of the most powerful and ambitious men of the period, Ludovico Sforza. Fourth son of Francesco Sforza, the condottiere who had obtained the duchy by marrying Bianca Maria, illegitimate daughter of the last Visconti, Ludovico ruled the state as regent for Gian Galeazzo, after whose death he was given the title. Cunning and unscrupulous, he expanded his power through alliances and marriages, forever weaving plots. He was to achieve his goal and become duke of Milan and the most influential ruler of Italy, but only briefly. These were dangerous times for Italy, looked upon as a field for conquest by European rulers, and Ludovico's boundless ambition, despite his notable political and diplomatic gifts, would lead to his downfall.

For the moment, however, fortune smiled on him, and he was in fact, if not in name, the ruler of the city of Milan, at the time Europe's third largest, after London and Paris, with almost two hundred thousand inhabitants. Its flourishing economy was based on agricultural production and the exportation of weapons, wool, and silk. The state coffers were full, supplemented by heavy taxes, and the Sforza treasury overflowed with silver, majolica, jewelry, works of art, tapestries, and illuminated

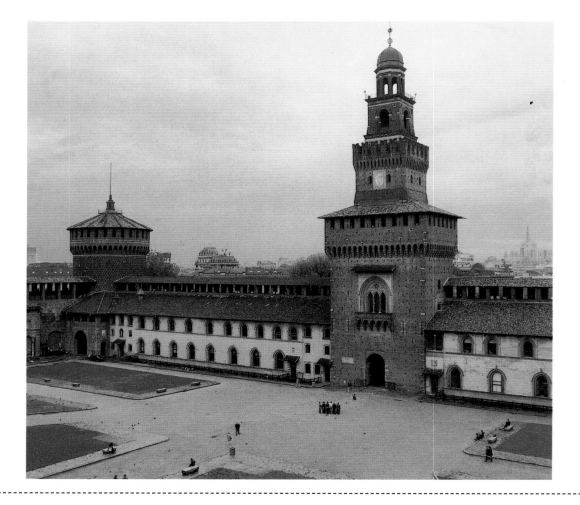

manuscripts, all of exquisite workmanship. The availability of apparently limitless wealth made possible the financing of construction work. There was the cathedral, work on which had begun in the fourteenth century, and there were also new buildings and decorative projects. In Pavia, which after Milan was the favorite residence of the Visconti and the Sforzas, work went ahead on the Certosa (Carthusian monastery) and the enlargement of the Biblioteca Viscontea, the library based on the Visconti collection of books. The Sforzas, with greater wealth to draw on than the Medici or perhaps any other Italian family, protected and supported men of letters, antiquarians, musicians, and artists. The emoluments for services rendered ranged from cash to the awarding of positions and benefits, gifts of precious objects, vineyards, or real estate. In addition to such material goods there was also the honor, along with the onus, of living at court, sharing the daily activities and entertainments of the duke and his entourage.

The elegant world of the duchy saw a continuous succession of festivals, banquets, hunts, and entertainments, both for the celebration of moments related to the Sforza family circle, such as baptisms, engagements, and weddings, and for such public activities as the reception of princes and ambassadors. The political aspects of these cere-

monies were not lost on Ludovico, cunning manipulator of people and events. A multitude of advisers, clerks, jurists, scribes, doctors, astrologers, maidservants, wardrobe attendants, grooms, jesters, dancers, and singers lived and worked in Pavia as in Milan: a large enough host to guarantee the bureaucratic-administrative functioning of the state and the material and spiritual well-being of its rulers.

In terms of art, however, the opulent capital of the prosperous domain was somewhat backward. This was most glaring in the field of architecture, where signs of the style of the Tuscan Renaissance had been only sporadic. Around the middle of the century, Piero de' Medici had recommended the Florentine architect Filarete to Francesco

Opposite: The Castello Sforzesco, Milan.

Above: *Lira da braccio* built by Giovanni d'Andrea in Verona in 1511; Kunsthistorisches Museum, Vienna.

Right: Leonardo, *Sketches of Musical Mechanisms* (detail); Biblioteca Nacional, Madrid.

the cultural point of view it lagged behind, and his arrival was to have many immediate consequences. In Milan, his multiform talents had room for full application, and he was free to explore a variety of fields of knowledge and research, spurred on by commissions, as well as by encounters with some of the most fertile minds of his generation, people who like him enjoyed Sforza patronage.

In all probability Leonardo had already met his new patron in Florence when Ludovico paid a visit to the city to express his condolences following

Sforza, and Filarete had built the Ospedale Maggiore in Milan and had also planned an ideal city, Sforzinda, which he described and illustrated in a treatise dedicated to Francesco. Another Florentine favorite of the Medici, Michelozzo, had made a building in Milan that was unrelated to the Gothic style reigning in the city, the Medici Bank (since destroyed), and also the Portinari Chapel in Sant'Eustorgio. Shortly before Leonardo's arrival, Donato Bramante had been summoned from central Italy. The Urbino architect-painter had introduced the principles of illusionistic perspective to Lombardy, contributing to a change in the representation of space.

The city Leonardo found was thus the center of attention of all Europe in terms of political events and was avant-garde in several respects, but from

the assassination of Giuliano de' Medici in 1478. Ludovico was well aware of what he could ask for from this Florentine master, since Leonardo had listed his abilities in a well-known document (Codex Atlanticus), written by an unknown hand but conceived and dictated by Leonardo himself. Addressing himself to "My Most Illustrious Lord," Leonardo begins by listing his abilities in nine sectors of mil-

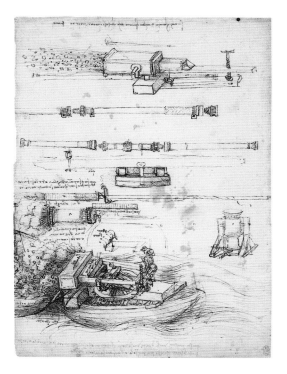

sculptor—in marble, bronze, and clay—and as a painter to the end of the list. The technical clearly outweighs the artistic, but the letter was going to a tough-minded ruler during hard times.

The disturbances then agitating Italy, and the duchy of Milan in particular, were a sign that the nonbelligerency pact established at the Peace of Lodi would not last long.

In 1482 Milan allied with the Este family of Ferrara in a war against Venice; the war led to the Venetian conquest of the Po River delta but also ended Venice's attempts to invade Lombardy. Perhaps Leonardo had intuited that in the eyes of Ludovico, son of one of the country's most valiant men-at-arms and himself a sage strategist, the services of a good architect and military engineer would outweigh any interest in an artist. Although

itary engineering, running from the design of portable bridges to removing water from moats and constructing cannon and mortars or, when needed, catapults and "other instruments of wonderful efficiency." He then explains that in times of peace he could easily give "complete satisfaction" as an architect, designing public and private buildings and canals. He relegates his activities as a

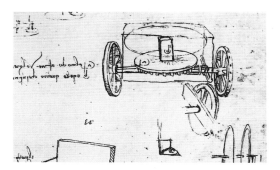

Opposite top: Leonardo, emblem of Galeazzo Maria Sforza (?), ca. 1495; Royal Library, Windsor.

Opposite bottom: Sforza coat of arms at the center of the vault of the Sala delle Asse, Castello Sforzesco, Milan.

Top: Leonardo, *Drawings of Mortars*, ca. 1483–85; Royal Library, Windsor.

Right: Leonardo, drawing, ca. 1485 (Biblioteca Ambrosiana, Milan) and model (Museo Nazionale della Scienza e della Tecnologia) of a "transmission for cart."

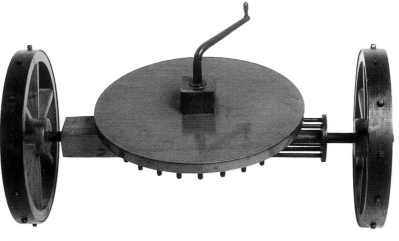

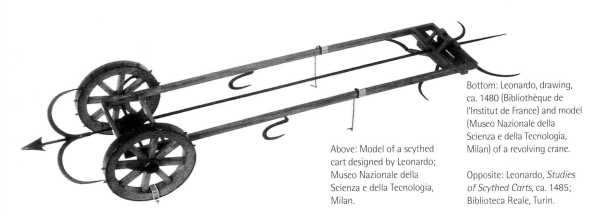

Above: Model of a scythed cart designed by Leonardo; Museo Nazionale della Scienza e della Tecnologia, Milan.

Bottom: Leonardo, drawing, ca. 1480 (Bibliothèque de l'Institut de France) and model (Museo Nazionale della Scienza e della Tecnologia, Milan) of a revolving crane.

Opposite: Leonardo, *Studies of Scythed Carts*, ca. 1485; Biblioteca Reale, Turin.

he had had no occasion to deal with military matters in Florence, Leonardo's education had involved the application of direct experience to the solution of technical and practical problems, and faced with the difficulties of acquiring book learning, he had come to prefer experience to theory and to seek knowledge in the world of artisan techniques to which he had far easier access. The situation in Lombardy proved congenial to the further development of his interests in that area. Leonardo had made pages of drawings of mechanical devices and war machines before his stay in Milan; some were crowded with generic contrivances, others were dedicated to the elaboration of specific and sometimes fantastic—but never impossible—war machines. The fabrication of weapons was a major sector of the Milanese economy, and the always-

active workshops lined up along the city's Via degli Armorai were capable of giving form to the most complicated design. Leonardo did not love war, but he supplied ideas for the construction of instruments of destruction; at the same time, he sought to improve the application of muscular energy, human and animal, and to this end designed instruments with peaceful, productive uses. After visiting the workshops of metalsmiths and founders and crossing the fertile cultivated plains of the peasants, he came up with ideas for new devices. He became increasingly absorbed in the design and construction of machines intended to serve a variety of uses and to solve the most diverse problems. Many of these were meant to meet the primary needs of the Lombard world—for example, a machine for the better cutting of fabrics—but oth-

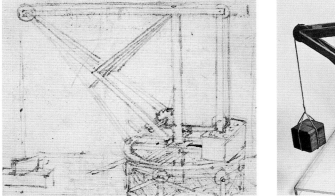

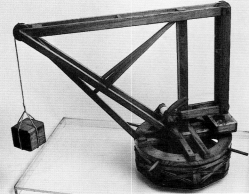

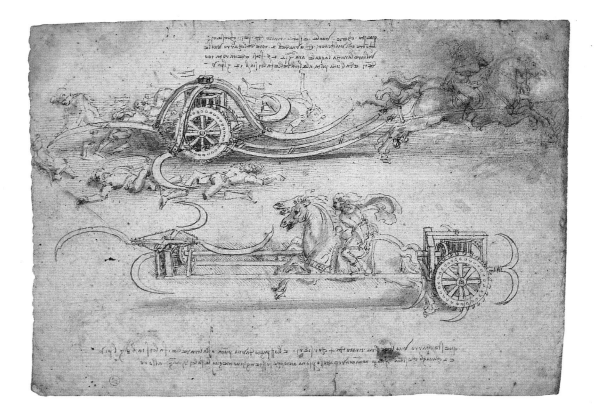

ers were based on personal inspiration, such as those, so evocative in the eyes of people today, for flying machines, a result of his studies of the flight of birds. Freed from the weight of the overly enthusiastic receptions they were once given, Leonardo's designs indicate that their creator was not so much an inventor as a technologist.

The perfect feasibility of many of Leonardo's designs has been established; others, although astonishing in the way they leap across the centuries and in the apparent simplicity of their underlying concept, could never have functioned. Many are not absolute inventions since they are "machines" that are derived from (and that improve) well-known common instruments, such as crossbows and ballistae, for which Leonardo designed improved tripping mechanisms and types of projectiles. Leonardo's age was one of transformation, both in

warfare, with crossbows and cavalry gradually giving way to harquebuses and cannons, and in the economy, with an increase in agricultural productivity and in manufacturing, and Leonardo contributed to the general change. His designs for canals for supplying water or for machines for lifting weights or for working stone or metal, designed to diminish fatigue, are part of an overall atmosphere of progress favored by the rationalization of mechanical work and by the reclaiming of new territory, such as the canals built across the Po River Valley.

Examining the effectiveness of Leonardo's technological designs over the arc of his career—and putting aside the difficulties in establishing precise dates for many of them—scholars have concluded that he made an important contribution to the history of technology, but that his activity in the sec-

tor must be seen in relation to the times in which he worked and to the accomplishments of other great engineers, most of all Filippo Brunelleschi, Francesco di Giorgio Martini, and Giuliano da Sangallo, since Leonardo was aware of their works, both concrete and theoretical, and sometimes corrected or improved them. With time, what came to interest—not to say obsess—Leonardo was understanding the universal laws behind the functioning of every type of machine. To achieve this goal, he perfected a graphic style with which he could present not only the machines but their elements and means of functioning. In doing so he laid the basis for technical draftsmanship, capable of expressing what he called "mental discourse." He applied his methods of scientific illustration to the analytical observation of meteorological phenomena, atmospheric elements, and living organisms, from plants to humans. After 1500, by which time he was far

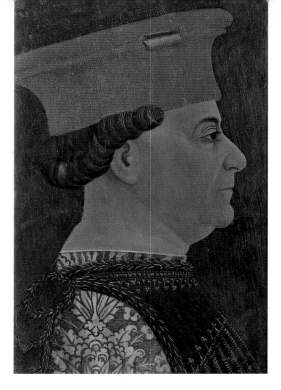

Below: Pollaiuolo, *Galeazzo Maria Sforza,* ca. 1460; Uffizi, Florence.

Above: Bonifacio Bembo, *Francesco Sforza,* ca. 1471; Brera, Milan.

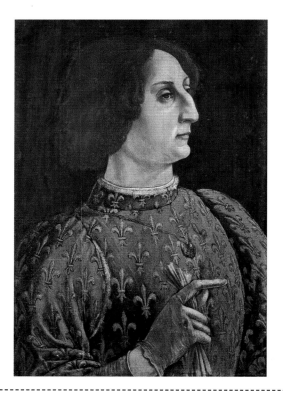

from Milan and had been enriched by further experiences, he took a more properly scientific attitude, free of immediate practical applications, leading him to begin a series of theoretical treatises dedicated to water, motion, weight, and geometry. The primary obstacle to anyone eager to dedicate himself to study is the nuisance of material concerns: having to earn a living. In all probability Leonardo agreed to the trip to Milan because it offered him the opportunity for a steady and healthy income, enough to let him maintain his anything-but-parsimonious lifestyle. Given his temperament, brilliant and friendly with those dear to him, but capricious, subject to sudden changes of heart, ready to give in to new stimuli even if not related to the desires of his sponsors, he needed a good income to provide him with the time and freedom to roam among a variety of fields.

While serving Ludovico he was free to accept commissions from outside the court. In fact, the first document attesting to his presence in Milan is a contract drawn up on April 25, 1483, between "Maestro Leonardo" and the brothers Evangelista and Ambrogio de Predis on one side and the prior and several members of the Confraternity of the Immaculate Conception on the other, for the exe-

Ludovico Sforza, Called "il Moro"
(Vigevano, 1452–Loches, 1508)

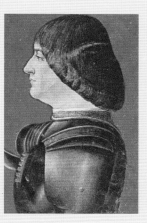

The Sforza fortune, amassed by the use of arms, began with Muzio Attendolo, a mercenary captain from Romagna who took the surname Sforza (the Forcer) and died in 1424 in the service of the queen of Naples. His son Francesco inherited his troops and became one of the most sought-after mercenaries of the time. He was financed by Filippo Maria Visconti, duke of Milan, and married his illegitimate daughter and only heir, Bianca Maria; thus he obtained the rule of Milan in 1450. Ludovico, known as "il Moro" (the Moor) because of his swarthy complexion, was the fourth born, and his time came after his brother, Galeazzo Maria, was assassinated in 1476. As guardian of his nephew Gian Galeazzo, he ruled the Milanese state, bringing it to the heights of political, economic, and cultural splendor and extending his influence to become a leading figure in the complex web of Italian and European alliances, which he skillfully orchestrated. Following the death under obscure circumstances of Gian Galeazzo in 1494, Ludovico was named duke by the council of nobles, receiving his imperial investiture from Maximilian I in 1495. His power seemed boundless until the French, under Louis XII, invaded Milan in 1498. Abandoned by his former allies, he fled the city, only to end his life in captivity in France.

Left: Ambrogio de Predis, *Ludovico Sforza*, from the Grammatica di Elio Donato, second half of the fifteenth century, Biblioteca Trivulziano, Milan.

Below: *Ceremony of Investiture of Ludovico il Moro*, miniature from the Arcimboldi Missal; Biblioteca Capitolare del Duomo, Milan.

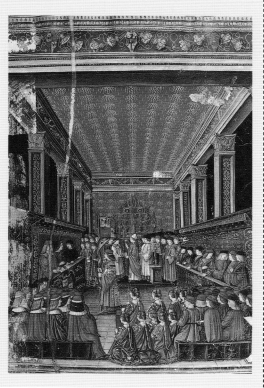

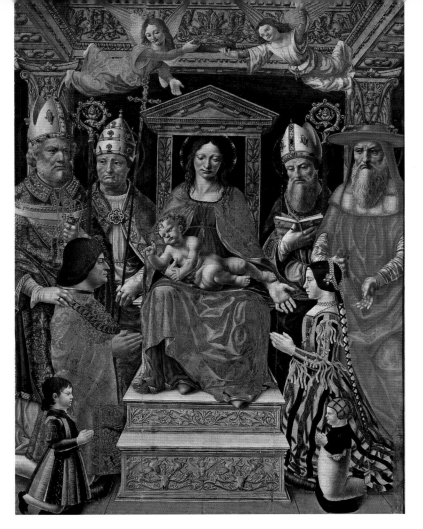

cution of three panels and the painting and gilding of the wooden parts of an altarpiece for the confraternity's chapel in San Francesco Grande, a Milanese church later demolished. The confraternity had arisen a few years earlier to celebrate the cult of the Immaculate Conception, which was quite popular and the object of particular devotion in the area of Milan but had not yet been given official recognition from the ecclesiastical hierarchy (it became dogma only in 1854). *The Virgin of the Rocks,* today in the Louvre, as well as another version of the same subject made around 1508 and today in the National Gallery of London, must be imagined set within an elaborate wooden structure,

a Gothic-style sculpted frame made by the carver Giacomo del Maino. According to the contract, Leonardo, the only one of the three artists referred to as "master," was given the central, arched panel; Ambrogio was to do the side panels, presenting two musician angels; Evangelista was responsible for gilding and painting the wooden parts. As related by a series of contemporary documents, a dispute soon arose between the confraternity and the artists, eventually leading to the second version of *The Virgin of the Rocks.* According to the most credible version of these events, the version in the Louvre, completed by 1486, was replaced by the one in the National Gallery, begun in the 1490s but

completely finished only around 1506–08.

Conceived by its patrons as a collaborative effort in keeping with the rigid guild rules in force in Lombardy, the work entailed obligations that became increasingly intolerable for Leonardo. Even so, the first *Virgin of the Rocks*, with its scene around a dark grotto, displays a highly new iconography. Indeed, Leonardo did not abide by the clauses in the contract, least of all in the treatment of light and color. Leonardo's drawings and writings on the study of luminous phenomena date to a few years after 1483, but clearly he had already begun to wonder about the nature of light and shadow and to develop a color method that began with the awareness that the same color can never be exactly repeated in nature since the light, humidity, and surrounding colors that affect its perception can never be identical. Tonal unity, obtained through the control of light sources and selection of the range and intensity of the colors, is here achieved for the first time in a complete way.

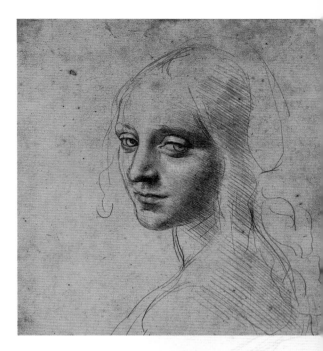

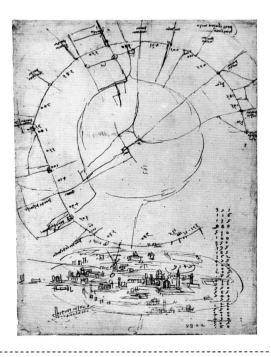

The Milanese public had little opportunity to view the panel, which may have left Milan in 1493 as a wedding gift to the new emperor, Maximilian, in the company of his bride, Bianca Maria Sforza, Ludovico's niece. With this marriage, made more appealing by a fabulous dowry, Ludovico sealed a valuable alliance and obtained the promise of the investiture of the duchy of Milan.

Although it spent little time in Lombardy, the painting influenced many artists, most of all Lombard, who made copies and works derived from it.

The second certain indication of a commission from Leonardo dates to 1487. This time it was his skills as an architect that were involved, as indicated by the payment for a model of the *tiburio* (crossing tower) of the cathedral, the most representative building in the city, on which he worked from July 1487 to January 1488.

Leonardo built two models. He abandoned the first and presented the second to the construction directors only to withdraw it a few days before the

The Virgin of the Rocks

The contract dates to 1483 and calls for the painting and gilding of a carved wooden altar for the chapel of the Immaculate Conception in San Francesco Grande in Milan, a church since destroyed, and for the painting of panels to be fitted into the spaces without sculpture. Leonardo was to create the central panel, presenting *The Virgin of the Rocks*, and in doing so he created a completely new iconography, the genesis of which can be traced in a series of drawings. In the end, as revealed by a series of documents exchanged

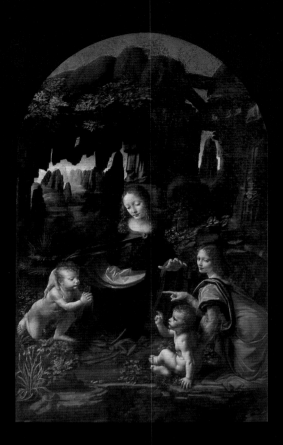

between the painters and the patrons, he made two versions, one in the Louvre, dated 1483–86 (77⅝ x 47⅝ in.) and one in the National Gallery of London, worked on at two different times, dating to 1495–1508 (73⅞ x 46¾ in.).

The Louvre version was the first to be made; how it arrived in France is not completely clear, but either it was never in the church of San Francesco or left the church soon after first being placed there; the second version was sold by the heirs of the confraternity to Gavin Hamilton in 1785, passing from him to the collection of Lord Suffolk and then to the National Gallery.

Going against the stipulations of the contract, Leonardo added the figure

of the young St. John the Baptist to the composition, thus illustrating a popular legend according to which the two had met as children during the flight into Egypt after escaping the slaughter of the innocents. Already a hermit, under the protection of the angel Uriel, St. John was said to have paid homage to the Child, receiving his blessing. The sacred and prophetic meaning of the event is amplified by symbolic references to the Baptism (the pond in the foreground), the Passion (the blade-shaped leaves of iris, prefiguring the pain to pierce the heart of Mary), and the Resurrection (the palm leaves). The rocks in the background are a metaphor for the manifestation of the face of the Virgin in the *Song of Songs*, frequently encountered in Marian iconography and particularly important to the cult of the Immaculate Conception. In keeping with the new doctrinal concepts of the confraternity, the most important figure in the pyra-midal group is Mary, whose role as protector is symbolized by the positions of her hands, the left above the blessing Child, the right on the shoulder of the kneeling St. John. The angel supporting Jesus on the edge of the pond looks out from the painting to invite the spectator to participate in the event, and in the painting in Paris she clearly points to the Baptist.

The significance of the formal and iconographic inventions can be understood in terms of the careful orchestration of the primary and secondary light sources, which shine on and illuminate the protagonists in a way that follows the directions indicated by their gestures and glances to form a dynamic network of attitudes and emotions. In the general prevalence of shadows over light, the contrast between the darkness of the background and the glowing light emanating from the figures gives them their volumes and confers on each the value of an apparition.

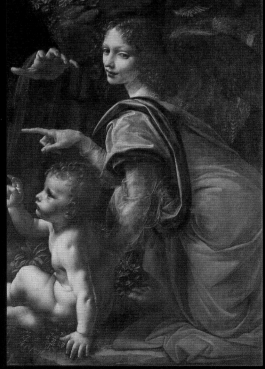

Opposite: Leonardo, *The Virgin of the Rocks*, 1483–86; Louvre, Paris.

Left: Leonardo, *The Virgin of the Rocks* (detail with the angel), 1483–86; Louvre, Paris.

Below: Leonardo, *The Virgin of the Rocks* (detail of flowers in foreground), 1483–86; Louvre, Paris.

competition, which was won by two Milanese, Giovanni Antonio Amadeo and Giovanni Giacomo Dolcebuono.

Also among the candidates were Donato Bramante and Francesco di Giorgio Martini, the leading architects of the period, with whom Leonardo was to have further contact and with whom he was to collaborate, a further proof of his willingness to take advice from a variety of sources. Leonardo's proposal—traces of both models remain in several drawings—was audacious and unusual, calling for a dome far different from those of the Lombard tradition and more similar to those of the Tuscan type. This is the only occasion on which Leonardo, highly esteemed as an adviser and consultant and involved in questions of architecture throughout his career, performed the practical role of designer-builder.

Thanks to the presence of so many important architects, the city of Milan was being transformed, but for Leonardo the basic point of reference in terms of architecture was still Filippo Brunelleschi, whose works he had seen during the earliest years of his apprenticeship in Florence (elements clearly derived from Brunelleschi have been found in some of Leonardo's youthful drawings). From Brunelleschi he took building formulas and ideas that led him to design a series of buildings with a central plan, the layout that Renaissance theorists considered the most harmonious and best suited for the construction of religious buildings. The figure of the circle embraced the metaphor of divine perfection, since it resembles the form of the cosmos, regulated by the divine laws of harmony and

Above: The cathedral of Milan.

Left: Medallion with bust of Filippo Brunelleschi; Santa Maria Novella, Florence.

Opposite: Leonardo, *Studies for the Tiburio of the Cathedral of Milan*, ca. 1487; Biblioteca Ambrosiana, Milan.

proportion. The fact that the buildings of the ancient classical past had been based on central-plan layouts made the design even nobler and more worthy of emulation. Using combinations of regular geometric shapes laid out and elevated in accordance with strict mathematical ratios, Leonardo created designs for churches that were never built but that had great influence on the religious archi-

the basis of his ideas, scholars agree that Leonardo opened new perspectives to his contemporaries and to his successors in the field of architecture. In some of his architectural drawings based on abstract geometric figures, the combinations of the separate elements resemble the diagrams drawn by musicians of the same period to present their musical harmonies. Other drawings, especially those that analyze individual architectural elements, show clear parallels to the anatomical drawings in which Leonardo "sectioned" various parts of the body, revealing a concept of human proportions according to which a human is a "lesser world," a microcosm that lives and acts, participating in the laws of universal harmony inherent in creation. The human body becomes the measure of all things, as presented in the famous drawing of the *Vitruvian Man,* today in the Accademia in Venice, dated to around 1490. Not only must architecture, based on a "human measurement," re-create an order analogous to that of the cosmos, but so must all the arts and the sciences.

tecture of the early sixteenth century.

Leonardo's notebooks are full of notes and sketches of architectural designs and models, and even though it is difficult to establish with any certainty whether any buildings were put up on

In Leonardo's tireless and receptive mind, a system for the organization of knowledge based on stimuli from the widest variety of fields of activity was beginning to take form. For the first time, around the end of the 1490s, he seems to intend to give a theoretical arrangement to all his many observations. His intention to compile a treatise on architecture appears on pages of the so-called Manuscript B, dedicated to the design of central-plan buildings, to the urban arrangement of Vigevano and Milan, and to fortifications. Beginning the habit of writing on different subjects at the same time, during this period his studies of human and animal anatomy were becoming increasingly expert, and he set about composing "on the second of April 1489 a book entitled 'On the Human Figure'" (Codex I).

THE COURT ARTIST

Given the enormous breadth and complexity of Leonardo's interests, it is surprising to find him involved in tasks that might ordinarily seem mundane, but doing so was an aspect of the life of the court artist, called on to be a master of all cultural expressions, from the most frivolous, related to daily amusements and entertainments, to the most solemn and official. Indeed, anyone living and working at court, whether artist, adviser, or functionary, had to subordinate his talents to the will

and whim of the prince, who might give him chores in his field of specialty or require him to do something completely unrelated. Thus someone about to depart on an important diplomatic mission might find himself called on to perform in a play, or a personal secretary could find himself transformed into a singer and musician. One of the qualities necessary for success at court was versatility.

Leonardo, who sometimes expressed his annoyance at being asked repeatedly to use the same

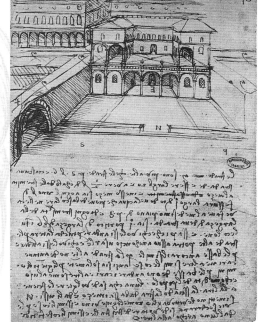

Left: Leonardo, *Design for a City on Various Levels,* ca. 1488; Bibliothèque de l'Institut de France, Paris.

Opposite top: Leonardo, *Study for the Monument to Francesco Sforza,* 1488–89; Royal Library, Windsor.

Opposite bottom: Leonardo, *Study of a Horse Seen from the Front,* ca. 1490–91; Royal Library, Windsor.

talent, was called on not only to act as architect, engineer, and painter, but also to display a wide variety of "courtly" talents. These talents, which today might seem minor, involved him in the creation of works that were ephemeral but that are essential to any reconstruction of how he spent his days in the Sforza castle, in the Sforza residences, or in the palaces recently built by Milanese nobles. During these years it seemed that all of Ludovico's

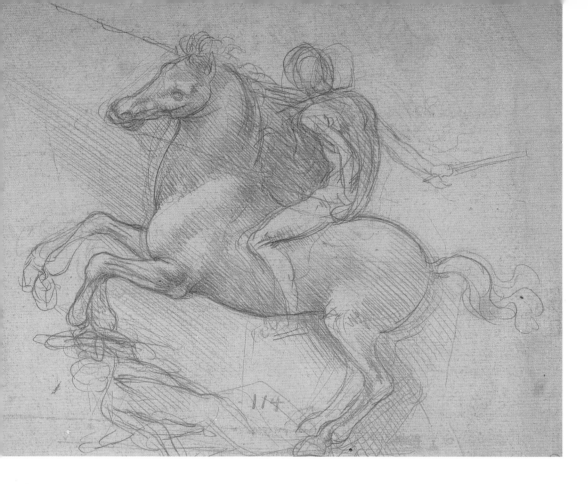

ambitious undertakings were destined for success, and he made this success clear by surrounding himself with luxuries and amusements. In the service of Ludovico and his intimates, Leonardo prepared celebrations and banquets; devised brilliant games, verses, and mottoes; and invented mechanisms that delighted and astonished. Among these many wonders, he himself mentions a water clock that awakens the sleeper by tugging sharply at his feet, a chemical trick for transforming water into wine, and a device for the bath of the duchess. The days at court were organized on the basis of a meticulous protocol that directed every moment, and when there were special events to be celebrated, such as baptisms and marriages, Leonardo packed these moments with sparkling inventions and representations designed to glorify the Sforza dynasty.

Leonardo

Study me, O reader, if you find delight in me, because on very few occasions shall I return to the world, and because the patience for the profession is found in very few, and only in those who wish to compose things anew. Come, O men, to see the miracles that such studies will disclose in nature.

(Madrid Codex I)

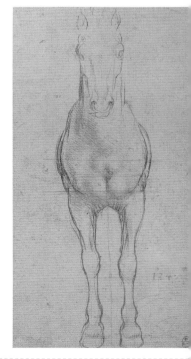

Early in 1490, the wedding of Gian Galeazzo Sforza, the young and inept duke of Milan, to Isabella of Aragon, niece of the king of Naples, consecrated the preceding year, was the scene of a series of entertainments. These included the staging of a theatrical show with a mythological character, the *Festa del Paradiso*, by the court poet Bernardo Bellincioni, who, recalling the event in his *Rime*, published posthumously in 1493, said that "the Paradise with all seven planets that turned" had been built "with great ingenuity and art by Maestro Leonardo da Vinci." In January 1491 Leonardo applied his talents to another marriage, celebrated with the usual

Sforza pomp, that of Ludovico to Beatrice d'Este. The sixteen-year-old daughter of Ercole, duke of Ferrara, sister of Isabella, marchesa of Mantua, established a tie between Ludovico, at the time able to style himself only duke of Bari, and one of the oldest and most illustrious ruling houses of Italy. This permitted him to reanimate his claims to the succession. Among the entertainments held for the new couple, which continued for several days, was a memorable joust designed by Leonardo, who also prepared the celebration in honor of the marriage of Anna Sforza, Gian Galeazzo's sister, and Alfonso d'Este, Beatrice's brother. A few years later he prepared the staging and costumes for the *Danaë* by Baldassare Taccone, Ludovico's chancellor. Leonardo was a true magician of theatrical techniques, capable of making images suddenly appear and move, and on this occasion the ingenuity and beauty of his artistry awakened the usual amazed admiration from the spectators.

Among the favorite court pastimes, pleasing to the vanity of the lords and based on a repertoire of iconography common to the noble houses of

Europe, was the creation of emblems, meaning coded images or visual puns presented in allegories, mottoes, or acrostics, alluding to the virtues and characteristic traits of the chosen person. Also called devices, these were created by the leading poets and artists, to be presented in homage to the powerful. Many of these were created for Ludovico—his nickname, "Moro," for example, could be used for identification with the black mulberry, a tree connected to a primary sector of the Lombard economy, the silk industry. But the most creative were those thought up for his brilliant sister-in-law, Isabella d'Este, the "first woman of Italy," a discriminating and demanding collector who, although not having access to the enormous wealth of her Milanese relatives, assembled in Mantua an exclusive court. Used to receiving the praises and works of the best artists, and a frequent visitor to the Milan duchy, she undoubtedly appreciated Leonardo's works and was soon doing her best to obtain a product of his genius for herself.

This desire was further stimulated by seeing his portrait of Cecilia Gallerani, a work she used in comparing his portraiture skills to those of Giovanni Bellini: it was Leonardo who got her preference. The image had been praised by the court poet Bernardo Bellincioni, and the marchesa had asked to see it. In sending it to the marchesa in 1498, Gallerani (born in 1473) added the explanation that it had been painted when she was still very young and that she had changed since then. Gallerani was a woman of great fascination and culture, the pride and ornament of Milanese high society, and a favorite of Ludovico. Documents attest to her relationship with Leonardo. It seems likely that the portrait in question was *Lady with an Ermine* in the Krakow museum, dated for stylistic reasons to around 1488–90. The model for the *Musician* in the Pinacoteca Ambrosiana, Milan, a young man absorbed by the emotion pro-

duced by a passage of music written on a slip of paper he holds in his right hand, was probably also a member of the Sforza entourage. Among the possibilities are Franchino Gaffurio, the most celebrated among the court musicians, author of a treatise on musical theory, cathedral chapel master, and personal friend of Leonardo, and Josquin des Préz, another celebrated musician and composer active in Milan. The last of these works in chronological order is the portrait of the mysterious woman today known as *La Belle Ferronnière*, identified with various women close to Ludovico, from Cecilia Gallerani to Beatrice d'Este, who died in 1497, to Lucrezia Crivelli, his lover beginning in 1496, a Milanese noblewoman that three anonymous

Below: Leonardo, *The Proportions of the Human Body According to Vitruvius*, ca. 1490; Accademia, Venice.

Above: Leonardo, *Man Standing, Kneeling, Seated*, ca. 1490; Royal Library, Windsor.

epigrams claim was painted by Leonardo.

The two women and the musician are the only individual portraits that most critics ascribe to the ten years from 1485 to 1495: very few in comparison to what must have been a far more numerous production. The collecting and exchange of portraits were widespread during this period, fueled in part by the increased communicative potential of portraiture. The increasing self-awareness of people during the Renaissance brought a new attitude to a genre traditionally reserved for the leading figures of sacred and profane history. Individuals, both male and female, could hope to be immortalized for reason of their beauty or other artistic appeal, not just their rank. There were still political-diplomatic uses (a ruler's image would be made widely known before he set foot in a territory he intended to protect or conquer; the features of two youths seen as a potential match were studied by relatives and courtiers before becoming betrothed and having occasion to meet), but to these were added more mundane and gallant uses,

such as spreading the images of famous beauties, women revered by princes, artists, and famous men of letters. The three portraits commissioned from Leonardo fall into that category. The fact that the identities of their subjects remain unknown matters little given their power as works of art capable of speaking across time to all viewers, capable of transporting viewers to a spiritual and aesthetic dimension with a validity beyond the mere evocation of a period of history and its customs. The genre of portraiture owed a great deal to the painting of northern Europe, which Leonardo had absorbed as early as his years in Florence, and the presence of Antonello da Messina in northern Italy sometime after 1475, including a stay in Milan, had given a further impulse toward more expressive portraits. Following Antonello's style of half-bust portraits set against a dark background, Leonardo opened new routes that were then followed by his collaborators and followers in Milan,

bringing a taste for "naturalism" to Lombard portraiture, understood as the subtle ability to communicate the state of mind of the portrayed and to establish an emotional relationship with the viewer.

Even when his ingenuity was being applied to what might be considered futile or trivial ends, Leonardo took the opportunity to freely apply his imagination and to carry out research dedicated to more elevated objectives. The "jests," the humoristic anecdotes full of double meanings, sometimes vulgar or coarse, written by Leonardo as well as by worthy poets and men of letters to amuse courtiers, are related to notebook pages bearing caricatures and to his many "grotesque heads." Far from being simple amusements, these testify to Leonardo's

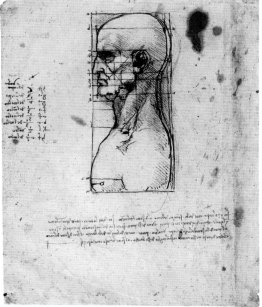

Above left: Leonardo, *Trunk of Man in Profile with Scheme of Proportions; Study of Horse and Riders,* ca. 1490; Accademia, Venice.

Above right: Leonardo, *Bust of Man in Profile with Study of Proportions,* ca. 1490; Accademia, Venice. This is the verso of the page to the left.

Three Portraits

"When you wish to portray someone, do it in dull weather or toward evening, and have the person to be portrayed keep his back to one of the walls of the courtyard. Pay attention in the street toward evening, when the weather is bad, to how much grace and sweetness can be seen in the faces of men and women. Therefore, O painter, use a courtyard where the walls are colored black" (Codex Ashburnham II). The three portraits Leonardo made during the period he spent at the Sforza court follow his instructions: the sitters are made to

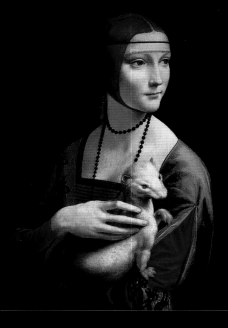

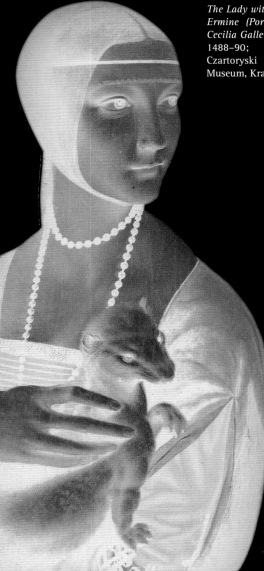

Above: Leonardo, *The Lady with an Ermine* (Portrait of Cecilia Gallerani), 1488–90; Czartoryski Museum, Krakow.

stand out against dark backgrounds by the application of intense illumination, and they radiate grace and sweetness. These works thus differ from the relatively static model of the "court portrait," presented in profile following the commemorative tradition of the medallion, and show instead a concentration of pictorial means.

The *Portrait of a Musician* in Milan's Pinacoteca Ambrosiana (16¾ x 12⅛ in.) and the portraits of the two women, preserved respectively in the Czartoryski Museum in Krakow (21⅜ x 15¾ in.) and the Louvre (24⅛ x 17⅛ in.), have been identified with three leading members of the cultural life and court of Ludovico Sforza, the most probable patron of these panels, made to immortalize people who were dear to him. *Musician* is believed to be the oldest of the three works, dated to circa 1485, in part because of the identification of the sitter as Franchino Gaffurio, made chapel master of the cathedral of Milan in 1484. It offers a first instance of Leonardo's compositional skills. The slightly oblique layout indicates the depth of the space, the hand holding the page of music establishes the foreground, and the glance is directed away from the viewer. The young man's face reveals his controlled but pow-

erful vitality, and his figure is constructed by means of the "counterpointing" of light that shows up with greater complexity in the two later portraits.

The Lady with an Ermine (Portrait of Cecilia Gallerani), dated 1488–90, is an image of unforgettable formal elegance. The pose of the woman, with her head and body twisting to one side, is repeated by that of the animal—the Greek name of which, *galee*, is a pun on the name of the sitter, Cecilia Gallerani—while the dark background is the result of a reworking by Leonardo, who initially painted a window behind the woman's left shoulder to provide a natural justification for the light source that molds her figure, presented in the act of turning.

The twisting effect is less apparent in the last of the three paintings, which also lacks a characteristic innovation of Leonardo, the presentation of the sitter's hands in the lower area of the painting. The work also differs from Leonardo's other portraits, including Ginevra

de' Benci or the profile of Isabella d'Este, in that it does not include even a symbolic element to help identify the model. The title *La Belle Ferronnière* was attributed to it on the basis of an erroneous reading of an eighteenth-century inventory, which confused it with another portrait, one showing the beautiful wife of an

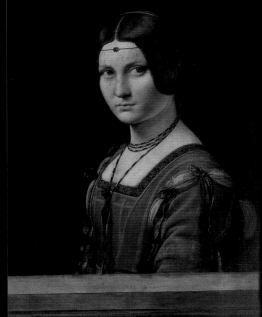

iron merchant who was the mistress of King Francis I. This woman probably belonged to the court of Ludovico Sforza. She has been variously identified as Lucrezia Crivelli, the duke's mistress, Cecilia Gallerani, and Beatrice or Isabella d'Este. The painting dates to the late period of Leonardo's stay in Milan, between 1495 and 1500; its sculptural grandeur and the woman's glance, which captures the viewer's eyes only to avoid them by looking to the right, are a prelude to the *Mona Lisa*.

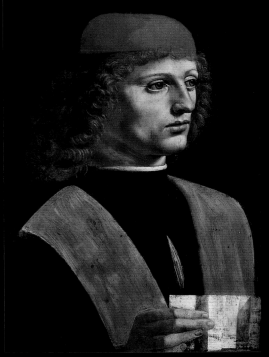

Left: Leonardo, *Portrait of a Musician*, ca. 1485; Pinacoteca Ambrosiana, Milan.

Above: Leonardo, *La Belle Ferronnière*, ca. 1495–1500; Louvre, Paris.

verses. These were extemporaneous compositions and no transcriptions of them remain, but we know that, after having learned the fundamentals of music in Florence, Leonardo continued to study that art at an advanced level, making use of the leading musicians at the Sforza court, first among them Gaffurio. His notebooks include musical notations and studies on the origin and propagation of sound. He also built musical instruments, most of all drums, designing mechanical drums for military use, as well as an instrument with cords and a keyboard, the "organ viola." He seemed particularly interested in creating soloist instruments capable of producing sound effects usually produced by groups of instruments and to this end are directed various sketches of instruments with three pipes for compressed air and organs with bellows. Designs pre-

desire to document, using such strongly characteristic features, the impulses and passions at the origin of human expression, the "motions of the soul" that he then eloquently rendered in individual portraits and in his larger paintings. Leonardo expressed his fantasy in the form of light and playful jests, mottoes, tricks, and witty tales; but he also saw fantasy as the source of artistic creations. It is typical of his complex and investigative nature that he subjected this faculty—fantasy—to scientific examination, eventually determining, after inspections of the human cranium, as indicated by a series of drawings dated to 1489, that it resides in the second cerebral ventricle, along with the "common sense" that is the faculty of reasoning.

According to period biographers, Leonardo also stood out at court for his gifts as a singer and composer of verses. An "exceptional player," he accompanied himself with the *lira da braccio,* a seven-stringed instrument, while he sang and improvised

Left and below: Leonardo, *Studies of a Skull,* 1489; Royal Library, Windsor.

Opposite: Leonardo, *Studies of New Types of Drum;* British Library, London.

senting "reeds" similar to the recorder have been related to the studies with cross-sections of the larynx and trachea, and from them was derived a new musical instrument, the glissando flute. On the basis of his anatomical studies he developed the idea, realized three and a half centuries later, of wind instruments with keyboards, imagining an analogy of form and action between the tendons of the hand and the metallic wires that would connect the keyboard to the cushions shutting off the pipe. Thus Leonardo can be considered an innovator also in the musical field, and in that field he demonstrated his usual ability to gather suggestions and associations of ideas from far-distant disciplines and combine them with extemporaneous stimuli to reach new ideas.

Clearly, Ludovico Sforza had many reasons for delighting in the presence at his court of a figure of the caliber of Leonardo. In addition, there was the construction of the long-awaited monument cited in the above-mentioned letter of presentation, in which Leonardo affirmed, "Also, work could be undertaken on the bronze horse that will be the immortal glory and eternal honor of the auspicious memory of His Lordship, your father, and of the illustrious house of Sforza." The "bronze horse" was the equestrian statue of Francesco Sforza,

Leonardo

It is a necessary thing for the painter, in order to be able to fashion the limbs correctly in the positions and actions which they can represent in the nude, to know the anatomy of the sinews, bones, muscles, and tendons in order to know, in the various movements and impulses, which sinew or muscle is the cause of each movement, and to make only those prominent and thickened.
(Windsor)

founder of the Sforza dynasty. The project had begun with Francesco's firstborn son, Duke Galeazzo Maria, who died in 1476 before work on the monument could begin. The idea had not been abandoned, and in 1484 Ludovico turned to Lorenzo de' Medici and asked him to send suitable sculptors. The search for an "excellent" master had begun during the period of Galeazzo Maria, and a letter of 1489 from the Florentine ambassador to Lorenzo de' Medici indicates that at a certain point Leonardo had been selected, but that Ludovico had requested another two other masters, whether to help Leonardo or in place of him is not known.

Designs dated from 1485 to 1489 indicate that Leonardo initially conceived the monument as a life-size rearing horse and rider, but the plan later took on a different, far larger form. The change is enclosed in the phrase "On April 23, 1490, I began

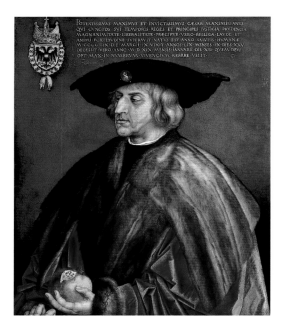

Above: Albrecht Dürer, *Maximilian I*, 1519; Kunsthistorisches Museum, Vienna.

Below: Leonardo, *Section of the Mold for the Head of a Horse*, ca. 1490; Biblioteca Nacional, Madrid.

sance artists, he decided to study the horses in the Milan stables, making many beautiful drawings of anatomical and proportional details. Casting and transporting such a colossal bronze work presented enormous difficulties, but after a great deal of meditation, documented by notes, sketches, and drawings, Leonardo seems to have resolved the problems through the use of a new method that introduced a variation in the traditional method that would become common beginning in the sixteenth century. The undertaking was to keep him occupied for many years, but due to events in the duchy of Milan, it was not to leave any concrete testimony. In the winter of 1493, celebrating the imperial wedding of Bianca Maria Sforza and Maximilian I, the terra-cotta model of the monument was exhibited in the cathedral, attracting enormous attention and approval: the competition with the ancients had been won.

this book and returned to the horse" (Codex C). He drew inspiration from ancient equestrian statues, but came to envision a monument far greater in terms of its size but also in terms of the naturalness of the representation of the shape and movement of the horse. Among the minor events of his days during the year 1490 we find, on June 21, a visit to Pavia and the Sienese architect Francesco di Giorgio Martini. Leonardo was there for a consultation concerning architecture at the city's cathedral, and he used the opportunity to study the only remaining ancient Roman equestrian statute outside Rome, the *Regisole*. He was struck most of all by the "free movement" of the horse, which suggested to him the pose of his horse, prancing instead of rearing.

To exceed the works of the ancients, which represented the greatest examples of art to Renais-

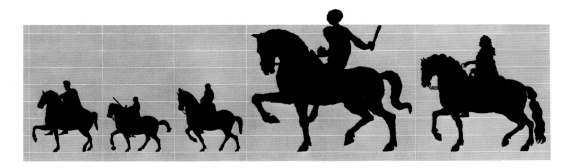

THE GREAT PICTORIAL UNDERTAKINGS

The progressive increase in his tasks and responsibilities created around Leonardo a network of increasingly varied relationships with new friends, collaborators, and assistants. Early in the new decade a new figure entered his life, destined to accompany him until the end of his days as both assistant and beloved friend: Gian Giacomo Caprotti da Oreno. He was only ten when he came to live with Leonardo in July 1491. Vasari described his youthful apprentice as "very attractive, of unusual grace and looks, with very beautiful hair, which he wore curled in ringlets and which delighted his master," but so wild that he merited the nickname

On July 16, 1493, his mother, Caterina, visited him in Milan. Although having created her own family, she never lost her affection for him. The woman died the next year and was buried at Leonardo's expense; Ser Piero died at the age of eighty in 1504.

The archives and Leonardo's autograph notes give the impression of continuous travels across the territories of the duchy, driven by his personal desire to get away from the city and by the many duties entrusted him by his prince. In 1493, perhaps accompanied for part of the trip by the wedding cortege of Bianca Maria Sforza, he went to Innsbruck and visited Lake Como, Valsassina, Valtellina, and the Val di Chiavenna. In 1494 he was at Vigevano, where Ludovico, who had been born in that city, wanted to have work done on the hydraulic works and to restore his country home, known as La Sforzesca, a magnificent villa and farm, which he had donated to his consort, Beatrice. Despite his credentials as a hydraulic engineer,

"Salai," meaning "devil." Leonardo nourished great affection for him, forgiving his every failing and satisfying his every caprice, while recognizing his character as "thievish, lying, obstinate, greedy." Aside from confirming Leonardo's homosexuality, the episodes involving Salai throw light on the intimate details of the daily life of a man who, loving all manifestations of beauty, was generous with himself and with others, surrounded himself with comforts and beautiful objects, and offered splendid gifts to those near him. Perhaps the most appealing anecdote concerning his personality is the one according to which he bought caged birds only to set them free: whether true or not, the tale is emblematic of Leonardo's respect for all living things.

it does not seem that Leonardo was involved in the design of the waterways of Vigevano, but rather in the urbanistic layout of the city, which was improved and reconstructed, beginning with the ducal palace.

Although it was not directly based on designs by Leonardo, the Sforza reworking of Vigevano, still very much in evidence in the city's historic center, reflects ideas from Leonardo, who was cited as being among the four leading engineers in the duchy during the last decade of the century.

The ambivalence of his role as *ingeniarius et pinctor* is revealed by the variety of ideas he applied to the most varied types of buildings, which are presented and dissected in notebooks full of notes and drawings of machines, weapons, military and civil buildings, all thought up during the same years in which he was working on two commissions for paintings from Ludovico. These are the decorations of the Sala delle Asse in the castle and *The Last Supper* in the church of Santa Maria delle

Opposite: Leonardo, *Head of Youth in Profile* (Salai?), ca. 1510; Royal Library, Windsor.

Above: Sala delle Asse (detail); Castello Sforzesco, Milan.

Below: Piazza Ducale, Vigevano.

Grazie, two very different works in terms of their intentions and outcomes. The first is an expression of courtly grace pervaded by heraldic allusions; the second, while also applauding the Sforza family, is primarily an expression of religious gravity and was made to express a universal message.

Finally proclaimed duke in 1494 following the death under suspicious circumstances of his nephew Gian Galeazzo, Ludovico wanted changes made to the castle, most of all on the northern side of the building, where he ordered the construction of an apartment composed of a series of small rooms connected by an open gallery and the readjustment of the large room known as the Sala delle Asse on the ground floor of the northeast tower. These rooms were destined for the duke's private reflec-

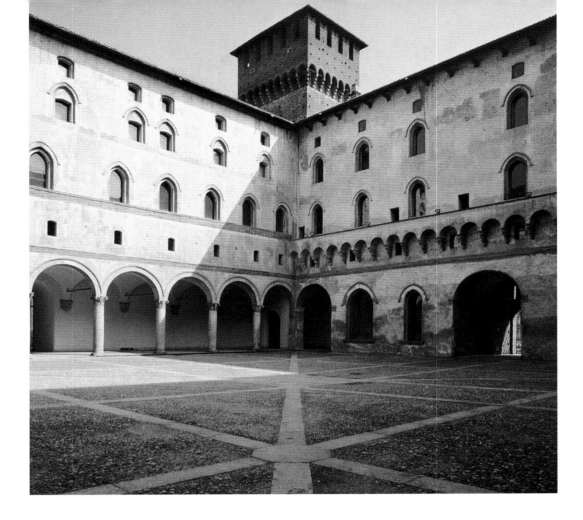

tion and entertainment rather than for courtly ceremonies, and in fact the duke was to withdraw to this area of the castle to give vent to his theatrical, but not necessarily insincere, grief following the death of Beatrice in 1497.

Period documents indicate that Leonardo also decorated various "little rooms," including the Saletta Negra, but the only surviving traces of his activity, which was far longer and more complex than what is visible today, survives in the Sala delle Asse. Identified at the end of the nineteenth century, the room was subjected to a restoration of the interpretive type at the beginning of the twentieth. This restoration involved a great deal of repainting to integrate what had been revealed fol-

lowing the removal of the plaster; if nothing else, it had the merit of bringing to light what has been called "the most ingenious pure decoration of the time." This was confirmed by later restoration, in 1954, that revealed that Leonardo had designed the whole even if he had not been involved in its actual execution (repeating identical plant motifs along the walls and vault would not have been a chore in keeping with his temperament and would have been entrusted to collaborators).

The ephemeral architecture used during court celebrations, such as the portico draped in greenery designed for the wedding of Gian Galeazzo and Isabella of Aragon in 1490, served as the basis for his design.

Backgrounds composed of interwoven flowers, leaves, and branches had been common in Gothic art, both in elegant illuminated manuscripts, such as those for which the Lombard school had been famous, and on the far larger surfaces of wall paintings. Leonardo went beyond this tradition, which limited the use of the vegetation to a kind of decoration, and created a "natural architecture," transforming the vault of the hall into an arboreal covering that spreads out from eighteen tree trunks along the walls to fill the room with a bursting vitality, today only partially ascertainable through the reconstructions of scholars. The dynamism of the growing vegetation that invades, envelops, and at the same time marks off the space is the result of his drawings of plants, true botanical studies, which he had been making since his early youth, and also of his love of geometric intertwining, in this case expressed by the golden rope that twists through the branches, creating a labyrinth of knots full of symbolic allusions. The knots have been compared to the "willow fantasy," one of the devices made for Isabella d'Este, based on a decorative motif composed of interwoven flexible branches of willow *(vinco)*, a clear allusion to victory. The "willow fantasy," which Leonardo adopted for his personal use, given the obvious reference to

his name, is only one of the styles started by the marchesa, an arbiter of Renaissance taste, and was copied by her younger sister for the embroidery on her own clothes. Ludovico's consternation following the death of Beatrice increases the evocative value of the profusion of knots in the room. The importance of the conjugal union and its consequences for the history of the noble family are repeated in the coats of arms and tablets positioned amid the foliage. Standing out on the central oculus is a coat of arms combining the arms of Ludovico with those of Beatrice, the green snake that swallows the red Saracen, the black eagle of the Holy Roman Empire, and the gilt lilies of France, and in the pendentives of the vault are four tablets in

Opposite: Courtyard of the Rocchetta; Castello Sforzesco, Milan.

Below: Vault of the Sala delle Asse (detail), ca. 1498; Castello Sforzesco, Milan.

Latin, one of which no longer bears its original text. These celebrate the marriage of Bianca Maria Sforza and Maximilian I in 1493, the transmission of the duchy from the Visconti to the Sforzas and the investiture of Ludovico by Maximilian I in 1495, and the victory over the French at Fornovo and Ludovico's journey together with Beatrice to Germany to seal the anti-French alliance in 1496.

Reading these tablets must have given Ludovico a great sense of pride, considering the obvious

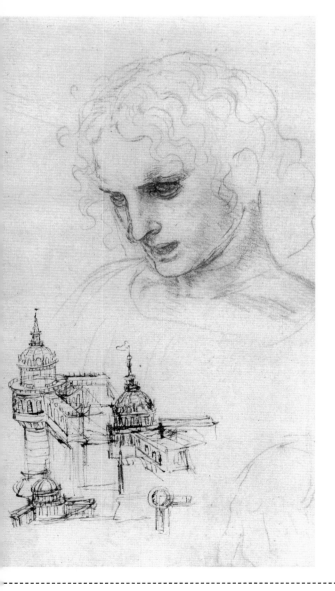

power attained by his family, begun by the warrior valor of his father, Francesco, who had married into an older, more illustrious family and had then been victorious over external enemies. It is also easy to imagine that worry overcame this pride, since the complicated web of intrigues he himself had woven was beginning to come apart. The original writing in the fourth tablet was replaced by words in memory of the dedication of Milan to Louis XII of France in 1499.

The treatment of Duke Gian Galeazzo, kept isolated in Pavia and deprived of any effective power, had not pleased Alfonso of Aragon, king of Naples, whose daughter Gian Galeazzo had married. Alfonso had gone from being an ally to posing a true threat.

This Neapolitan hostility called for a timely response. It was for that reason that Ludovico had supported the Angevin claims to the throne of Naples, favoring an expedition led by Charles VIII. The French had been welcomed at Asti and deviated to Florence, where the people had arisen against the Medici and proclaimed a republic. The French had then forced a difficult peace treaty on Pope Alexander VI before finally taking possession of Naples. Following the providential death of Gian Galeazzo, Ludovico had finally obtained the ducal crown.

When the French then posed a threat to the duchy of Milan, Ludovico changed sides, joining the Holy League composed of Pope Alexander VI, Venice, Maximilian I, and Ferdinand of Spain. The league's army defeated the French at Fornovo, near Parma, the Aragon troops reoccupied Naples and massacred the remaining French, and Charles VIII returned to France, where he died while preparing for another expedition. From then on, despite the support of his relative-by-marriage Emperor Max-

Opposite: Leonardo, *Study for a Male Figure with Architectural Designs* (Castello Sforzesco?), ca. 1492–94; Royal Library, Windsor.

On this page, the three lunettes over *The Last Supper*, 1494–97; Santa Maria delle Grazie, Milan. Left: Left lateral lunette with inscription relating to Massimiliano Sforza. Below: Right lateral lunette with inscription relating to Francesco II Sforza. Bottom: Central lunette with inscription relating to Ludovico Sforza and Beatrice d'Este.

imilian I, and despite Fornovo, a battle as invigorating for Italian self-esteem as it was meaningless on the concrete level (so uncertain was the outcome that both sides claimed victory), Ludovico felt his fortune vacillating. Even so, he did not give up and instead displayed his usual self-assurance, determined to fight it out.

This change in political realities forced Leonardo to put aside plans for the equestrian statue: the bronze necessary for the casting was not available in 1494, all of it having been sent to Ercole d'Este to make cannons to use against the French. In 1496, in financial straits because of the work on the horse and in the castle apartments, Leonardo asked the duke for the two years' salary owed to him and to his workers. Short of funds, the duke gave him a vineyard in the suburban area between the Grazie and San Vittore churches.

Despite all this, the tenor at court did not change and work was not lacking.

Leonardo's second pictorial undertaking for Ludovico, *The Last Supper* that is painted on the northern wall of the refectory of Santa Maria delle

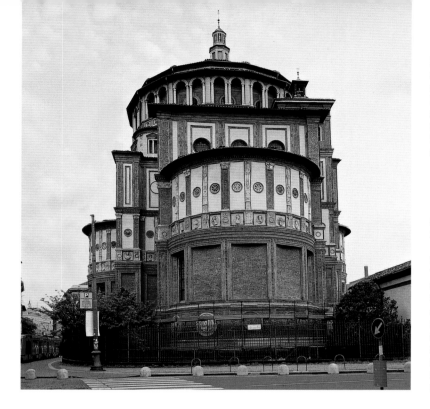

Left: Santa Maria delle Grazie, Milan. Construction of the monastic complex, located in a vast area outside the circle of medieval walls, started in 1463, during the rule of Francesco Sforza.

Opposite: Donato Montorfano, *Crucifixion*, 1495; refectory, Santa Maria delle Grazie, Milan. The tradition according to which Leonardo painted the figures of Ludovico with his firstborn son, Massimiliano, to the left, and Beatrice and their second son, Francesco, on the right, dates to Vasari, who visited the refectory in 1566.

Grazie, is related to the decoration in the Sala delle Asse. That the patron was the duke can be deduced from the location of the work and the interest Ludovico demonstrated in its progress.

During the last decade of the century, Ludovico showed great interest in the church and the related Dominican convent, intending to use it for his family chapel and burial place. In 1492 he had Bramante reconstruct the choir in a Romanesque-Gothic style like the rest of the building, constructed between 1462 and 1482 by Guiniforte Solari. Bramante's addition—an enormous, centrally planned tribune with a dome, under which Ludovico located his own tomb and that of his consort—is unavoidably reminiscent of Leonardo's drawings of central-plan buildings.

The architect Bramante and the painter Leonardo thus left in Milan works of exceptional novelty.

The exact date on which Leonardo began the painting, traditionally set at around 1495 but moved up by at least a year on the basis of recent scholarly research, is unknown, but he is known to have stopped working on it sometime between the end of 1497 and the beginning of 1498. No known documents confirm the commission for the work or any payments received for it, but there are several addressed to Leonardo entreating him to complete it. On the opposite wall Donato Montorfano had painted his *Crucifixion* in 1495, and in 1497 Leonardo had been asked to work on that side, perhaps to add the figures of Ludovico, Beatrice, and their children, Massimiliano and Francesco, at the two ends of the *Crucifixion;* the figures are there, but in poor condition, and cannot be attributed with certainty to Leonardo. Coats of arms and inscriptions alluding to the Sforza appear amid garlands, leaves, and fruit in the lunettes over *The Last Supper* and along the tops of the contiguous walls. The Sforza presence is thus quite strong in the room, and the duke is

known to have been in the habit of eating in the refectory twice a week while closely following the progress of the work. His concerns were justified by Leonardo's work habits, as described by the novelist Matteo Bandello, who saw Leonardo at work on the scaffolding. According to Bandello, on some days Leonardo arrived at sunrise and stayed till darkness, never laying down his brush and forgetting to eat or drink; several days would then pass in which he did nothing at all except examine and criticize his figures for several hours before leaving the refectory. On other occasions he would climb onto the platform, take a brush, give a few touches to one of the figures, and leave. From Bandello we know that Leonardo was busy at the same time at the Corte Vecchia of Castello Sforzesco on the execution of the terra-cotta model for the horse.

The Last Supper presents a summation of Leonardo's research up to that moment, but it was destined to almost immediately suffer from the climate, a situation made disastrous by the experimental technique employed and by the negligence and incivility of others. Restoration has recently greatly improved its state. It is not as it was—that appearance was lost soon after it was made—but it is now legible enough to permit an understanding of Leonardo's original meaning and intentions.

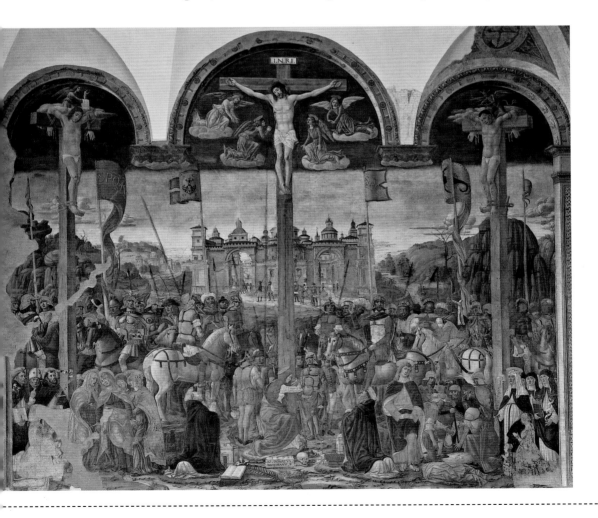

The Last Supper

In the last decade of the fifteenth century, when Ludovico Sforza entrusted the painting of *The Last Supper* to Leonardo, it was traditional to decorate monastic refectories with an image of that Biblical moment. Leonardo approached the theme with absolute freedom and originality and created one of the most intensely emotional works of Western art.

The physical history of this famous wall paint-

The physical environment, tampering, the use of the refectory as a stable, the injuries suffered from soldiers quartered in the space, bombardments during World War II, and numerous inadequate restorations have done serious damage to the pictorial surface, increasingly compromising its legibility.

The most recent restoration began in 1977 and was completed in 1999. Aside from bringing back much of the work's aesthetic value and creating a setting appropriate for its preservation, this operation revealed details of exceptional executive skill and

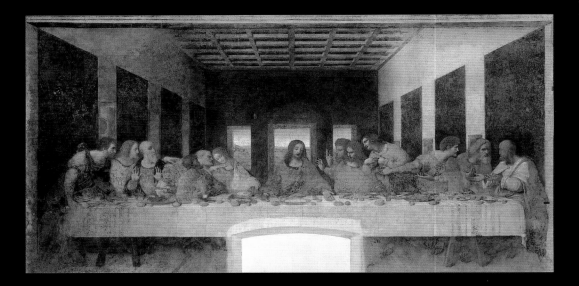

ing (179⅜ x 343¼ in.) is well known: sixteenth-century witnesses report that it was already coming undone a few years after its completion because of the technique used, which was not that of *buon fresco* but rather of an oil painting done on a preparation not suitable to receive it, a technique chosen by Leonardo because it allowed him to apply the paint slowly and made possible reworking and frequent changes.

further clarified Leonardo's procedure. In this work he summarized his scientific research in the fields of geometry, optics, and anatomy. The real space of the refectory and the illusory space of the painting blend through the use of a point of view located where a hypothetical spectator can take in the entire scene and focus on the important points, meaning the gestures and expressions through which the apostles respond to the revelation just made by Christ. The illu-

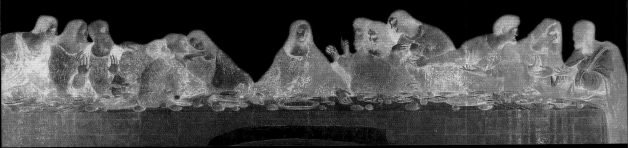

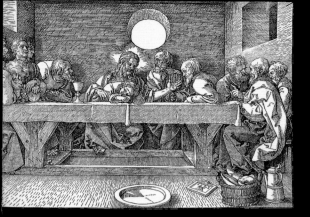

emotional reaction. At Christ's words, "One of you will betray me," Bartholomew, at the far left, rises to his feet, and James the Lesser and Andrew sit up straight; then comes the group of Judas sitting between Peter and John. Peter leans forward to touch John's shoulder; John lowers his head; Judas draws back. On the opposite side of Christ, James the Greater responds by opening his arms, forming a barrier that contains the questioning gesture of Thomas, with his raised index finger, and Philip, who clasps his hands to his

mination comes from two sources, the openings in the background and the window on the left wall of the refectory itself. In this way the figures, located between two areas of light, gradually acquire relief, and the colors of their clothes are reflected on the plates and glasses on the table in a wonderful play of light.

The main characters of the drama occupy the lower band of the painted surface, most of which is taken up by the empty space behind them; standing out against the horizontal line of the table, their busts rise upward to make them seem slightly oversized, most of all the figure of Christ. He is the center of the work and also the starting point for a series of emotional shock waves that run along the row of apostles, arranged in a slightly descending

chest. The final group is composed of a colloquy among Matthew, Jude, and Simon, caught in attitudes that amplify the distressing meaning of the revelation. Christ gestures toward the table in front of him, on which bread and wine stand out, creating an ingenious synthesis of the announcement of the betrayal and the institution of the Eucharist.

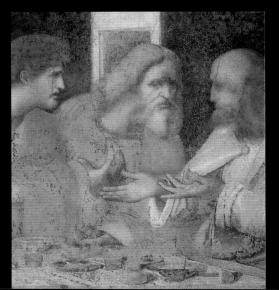

Opposite, left, and above: Leonardo, *The Last Supper* (entire and details), 1494–97; Santa Maria delle Grazie, Milan.

Top: Albrecht Dürer, *Last Supper*, 1523; Albertina, Vienna. Dürer is only one of the many artists who have drawn inspiration from Leonardo's *The Last Supper* over the course of the centuries.

The Last Supper met with an immediate favorable response; the people waiting to see it formed lines then, just as they do today. One of the first and most significant reactions awakened by the painting was that of Luca Pacioli, the friar-mathematician author of De Divina Proportione (1509), which begins with a dedicatory letter to Ludovico on the basis of which the painting is known to have been completed by February 8, 1498. Pacioli's admiration is based on the vivid depiction of the apostles, who respond to the announcement of the coming treason with "clear and sorrowful acts and gestures, one to the other and that one to the next, so vivid they seem to speak." Pacioli states that he had worked with Leonardo, and, like him, been in the pay of Ludovico, from 1496 to 1499. The two men became friends and formed a fertile professional relationship. Leonardo made the five polyhedrons that illustrate the De Divina Proportione and turned to the friar for help in improving his knowledge of geometry. Study of Pacioli's De Arithmetica was of great help to Leonardo, permitting him to bypass the Latin translation of Euclid. Geometry was not the only discipline attracting Leonardo. During the final decade of the fifteenth century, the Sforza court became the scene of scientific discussions in which he actively participated and which show up in The Last Supper, which can be taken as a visualization of his research in the fields of mechanics, acoustics, perspective, the propagation of light and sound, and physiognomy. It is always clear in the works of Leonardo that they are based on a vast range of unusual knowledge.

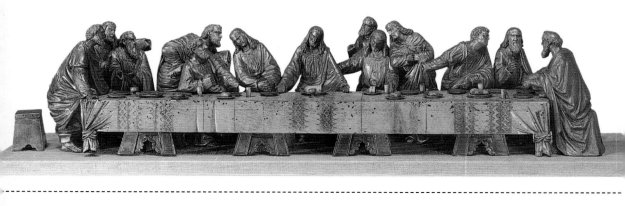

that on February 9, 1498, a debate took place at the Castello Sforzesco on the comparison of the arts and that Leonardo took part in this "laudable duel." This subject—the determination of which form of art was superior—was inspired by similar comparisons discussed by the ancients, and this connection to antiquity put it among the favored themes for debate, sure to give an elevated tone to courtly conversation and to interest all those who were interested in art and culture. On the basis of the anecdotes related by Pliny the Elder in his *Natural History*, primacy was given to painting, but this depended on the mimetic skills of the painter, his ability to make his figures appear real. Leonardo participated in this debate, his authority on the subject based on the works he had made—until then not so many, but such to make him the greatest Milanese painter—and he provided arguments matured over long reflection, as indicated by his many notes on the comparison of the arts. He returned to the subject many times (for example,

Left: Daniel Spoerri,
Last Supper, 1988;
private collection, Paris.

Below: Andy Warhol,
Last Supper, 1986;
Credito Valtellinese, Sondrio.

FROM PRACTICE TO THEORY

According to Matteo Bandello, on one occasion in 1497, Leonardo left off work on *The Last Supper* and came down from the scaffolding to pay his respects to a cardinal and several gentlemen then visiting the refectory. In the ensuing conversation, "they spoke about many things, and in particular the excellence of painting." Luca Pacioli relates

Opposite top:
Jacopo Bassano,
Last Supper, 1546–48;
Galleria Borghese, Rome.

Opposite bottom:
Lombard carver, *Last Supper*,
late sixteenth to early
seventeenth century;
Collezione Longari, Milan.

in the pages of the Codex Ashburnham and Codex Urbinas), making more extensive notes on it than on any other theme. There was nothing new about the reasoning Leonardo employed, but the importance of his discourse—or, rather, of the hypothetical discourse he might have held before Ludovico and his court—is that the defense of the supremacy of painting becomes a proclamation of his merits as an artist.

The power of the figurative arts results from the supremacy of vision over the other senses—affirmed by Aristotle and repeated many times over the centuries—and since the eye, as Leonardo wrote, "is said to be the window of the soul" and is the primary organ, with the ear secondary, painting thus takes first place over poetry and music.

To reinforce this thesis, he adds that the beauty created by the painter is perceived immediately, unlike that created by the poet, who, using "less worthy means than the eye," creates works that are perceived "more laboriously and more slowly." Furthermore, the beauty of paintings is not "so impermanent or rapidly destroyed as that made by music," and instead has "great permanence." Among the visual arts, painting wins over sculpture because the sculptor does not make use of

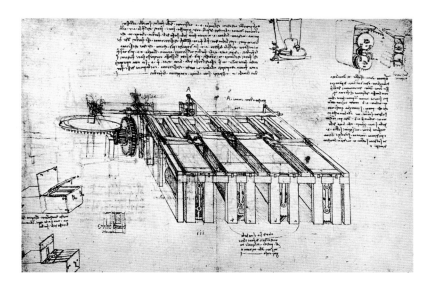

Opposite: Jacopo de' Barbari (?), *Luca Pacioli*, 1495; Capodimonte, Naples. Leonardo and the famous mathematician were close friends and shared many experiences after their period together in Milan.

Right: Leonardo, *Design of a Machine for Cutting Fabric*, ca. 1497; Biblioteca Ambrosiana, Milan.

Below: Leonardo, *Drawings and Notes on Mechanics*, ca. 1495–97; Accademia, Venice.

colors and "aerial perspective is absent from the sculptor's work," such that his art has "less discourse . . . and requires less mental deliberation." Furthermore, sculpture is not suitable for a gentleman since it is a "mechanical operation" that dirties, weakens, and physically tires the artist. The result is that painting must be admitted among the liberal arts and that the dignity of the painter is reinforced.

The discussion of the comparison of the arts reveals the importance to Leonardo of reflection on the theory behind his work. As has been shown, he had begun to sense the need to give written form to his research as early as 1489, when he made a rough outline for a treatise on the human figure. With the passage of years, his habit of returning to and reconsidering what he had already done increased. According to Pacioli, in 1498 Leonardo had just finished a treatise on "painting and human movement." This work, which may well have contained a systematic presentation of Leonardo's theories, a sort of compendium of what he called the "science of the painter," was perhaps absorbed into the growing mass of written pages and was never

published. He continued to dedicate himself to various studies, covering sheet after sheet and notebook page after page with observations and speculations. In August 1499, for example, he was working on "movement and weight."

The *Treatise on Painting* to which we turn for Leonardo's ideas on the fundamental techniques of

SEPTVAGINTA DVARVM
BASIVM VACVVM.

XL

treatises Leonardo expressed his intention to compile—is connected to a tradition of artists writing treatises. These include Piero della Francesca and his *De Prospectiva Pingendi* and Lorenzo Ghiberti, author of the *Comentarii;* Filarete wrote a twenty-four-volume *Trattato di Architettura;* Francesco di Giorgio Martini wrote a book on civil and military architecture; and Roberto Valturio wrote *De Re Militari,* a work well known to Leonardo. There are then the three volumes *De Pictura, De Statua,* and *De Re Aedificatoria* by Leon Battista Alberti. Influenced by Francesco di Giorgio Martini and

Left: Leonardo, *Drawing of a Platonic Regular Body* to illustrate the *De Divina Proportione* of Luca Pacioli; Pinacoteca Ambrosiana, Milan.

Below and bottom: Leonardo, *Drawing of an Eight-Barreled Cannon,* 1480–82 (Biblioteca Ambrosiana, Milan), and model (Museo Nazionale della Scienza e della Tecnologia, Milan).

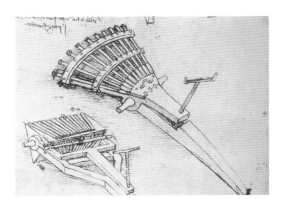

the artist was not compiled until after his death and was in fact made by his disciple Francesco Melzi, who selected material from among what Leonardo had left and organized it into a single work.

In all, Melzi selected notes from eighteen manuscripts, only seven of which are available today. Indeed, the sources for more than half of the material in the *Treatise* cannot be traced back to the known Leonardo manuscripts. Reading the *Treatise,* which was published in Paris in 1651, 132 years after the death of Leonardo, puts the reader in contact with the evolution of Leonardo's thinking and his painting; the mental processes revealed in the text have their physical echoes in the drawings and paintings. The *Treatise* is also one of the most interesting examples of vernacular Italian prose from the Renaissance, composed of figurative expressions, arcane references, repetitions, and clarifications. The *Treatise*—like the many

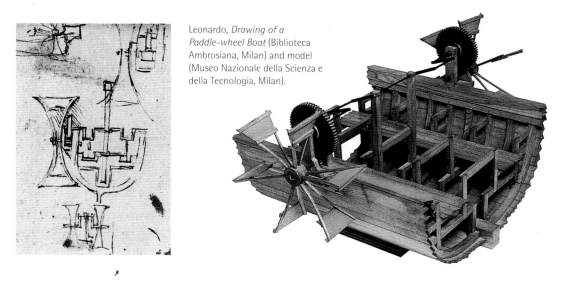

Leonardo, *Drawing of a Paddle-wheel Boat* (Biblioteca Ambrosiana, Milan) and model (Museo Nazionale della Scienza e della Tecnologia, Milan).

indebted to Valturio for his sections on military architecture, Leonardo stands apart from all the other treatise-writing artists because of his desire to put every science, every reflection, and every philosophy together to form a "universal" discourse that would converge on painting.

Altogether, there are more than five thousand pages of Leonardo's random thoughts, including notes and drawings. Many others have been lost, and not just those that Leonardo left to Melzi or that were dispersed following Melzi's death in 1570, but also the many that made it into the hands of other people while Leonardo was still alive. The transmission and reverberation of his ideas first began, of course, by way of his works, which had a wide-ranging and immediate effect, even in the case of works left unfinished or at a germinal stage, mere sketches and rough drafts. Unlike Michelangelo, Leonardo was not in the habit of saving the drawings, cartoons, and outlines he made for his artistic inventions and jealously guarding them from the eyes of others. In Milan he was the director of a large workshop, visited for differing reasons by many assistants, from Salai to Francesco Melzi to Giovanni Antonio Boltraffio, and draw-

ings of every type were kept in the atelier, including those of Leonardo's students, and the exchange of such drawings was encouraged. The so-called Leonardesque artists were a group of painters and sculptors who at certain periods of time in their careers and at varying levels of intensity experienced the influence of Leonardo. Some worked in close contact with him, others reacted indirectly to his ideas. Some followed Leonardo's methods rigidly, absorbing not just the themes and techniques but the most profound psychological implications; others grasped only the most immediate and superficial aspects, copying the originals almost to the letter.

To the art historian, the Leonardesque artists and Leonardism represent an area of research that has not yet been fully explored. There is a vast number of replicas and works based on lost works by the master; some works are known only from citations in antique catalogs or references made by Leonardo himself; there are paintings that were seen and described by reliable sources but are unknown today.

No artist in Milan was unaware of the novelties Leonardo had introduced, and well before the

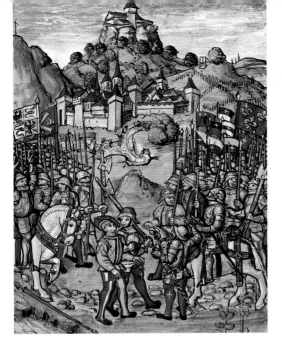

end of the century, even before *The Last Supper,* he was being referred to as "a new Apelles" because of the contribution he had made to the flowering of a wonderful season of Milanese culture, a season that was brought to a sudden end by the rush of historical events that led to the downfall of Ludovico Sforza.

The French threat, averted a few years earlier, returned, and this time there was no escape. France's new king, Louis XII, reconfirmed Charles VIII's claims to the kingdom of Naples and added his own to the duchy of Milan, based on his descent from Valentine Visconti; he proclaimed Ludovico Sforza a usurper who had to be deposed. Under the command of Gian Giacomo Trivulzio, the French moved into Lombardy, their easy advance a clear demonstration that the defensive tactics of

the condottiere were of little use in the face of soldiers armed with bombards and culverins. In September 1499 Ludovico abandoned Milan; the commander he left in charge handed over the city to the invaders in exchange for money. The treason was completed with the about-face of Venice and the pope, who conspired with the French to divide up the territories of the duchy. Francesco Gonzaga in Mantua and Ercole d'Este in Ferrara aligned with the victors in the hope of sparing their lands a ruinous invasion. On October 6, 1499, Louis XII made his triumphal entry into Milan. Ludovico sought refuge with Emperor Maximilian and with his assistance organized a brief offensive. Defeated at Novara, he was betrayed by the Swiss mercenaries he had hired and taken prisoner. He was deported to France, where he spent the rest of his life. His children and heirs sought exile with the Holy Roman emperor. Thus, to use Leonardo's own words, the man who had been the most important ruler in Italy, and had seemed destined to rule Europe, had "lost his state, his personal possessions, and his liberty, and none of his enterprises have been completed." Among the works begun

Top: Capture of Ludovico Sforza, from the *Lucerne Chronicle* by Diebold Schilling, 1513; Zentralbibliothek, Lucerne.

Right: Leonardo, *Drawing of a Mortar;* Biblioteca Ambrosiana, Milan.

Opposite: Leonardo, the Ligny Memorandum, 1499; Biblioteca Ambrosiana.

under his rule that were never to be completed was the reconstruction, including the naves, of the church of the Grazie, a project that went no further and that would have involved the contribution of Leonardo.

Leonardo greeted the arrival of French troops with neither dismay nor precipitous flight. While the new rulers piled up spoils and demanded ransoms, Leonardo went about his business, remaining in the city for more than three months after its surrender. He was planning to leave, as indicated by the fact that on December 14, 1499, he sent six hundred florins to Florence with instructions that the money be deposited in his bank account. The French archers used the "clay horse" as a target. In 1501 the duke of Ferrara tried in vain to obtain the hollow mold and the clay model for his own equestrian monument, after which all trace of the work is lost. Its author, however, did not escape the attention of Louis XII. The French king admired *The Last Supper* so much that he proposed carrying it off and eventually drew up a financial agreement with Leonardo to engage his services.

The so-called Ligny Memorandum dates to

Leonardo's last days in Milan. This is a sheet already partially occupied by a drawing on which Leonardo, using mirror writing, noted his plan to meet Louis de Ligny in Rome and accompany him to Naples (Codex Atlanticus). Ligny, count of Luxembourg, was part of the retinue of Louis XII and was in Milan during the days of the occupation. In meeting him, Leonardo had thus decided that his future would be with the French, from whom he would receive many commissions following his departure from Milan.

After eighteen years of service, and accompanied by his friend Luca Pacioli, Leonardo left Milan. He took with him in his luggage a great many drawings. By way of these drawings, and by way of the presence of Leonardo and the Leonardesques—each of whom set off for other corners of Italy—the influence of the master was greatly expanded.

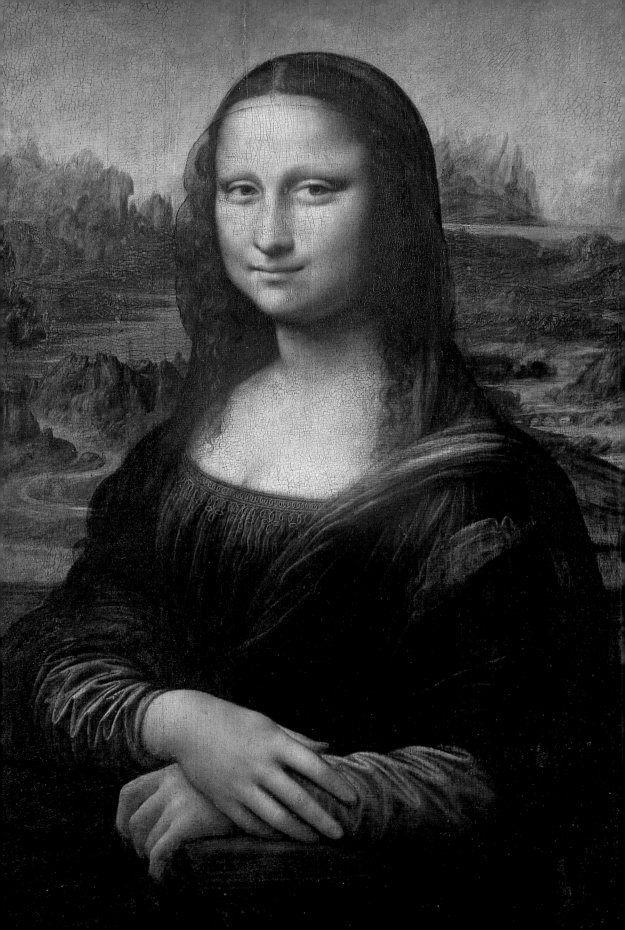

1500–1508
New Experiences, a New Century

*Leonardo is the most versatile
and influential artist of his time,
sought after and contested throughout Italy.*

To Florence: Mantua, Venice, Rome

The second French invasion wrought large-scale changes throughout Italy, which became the scene of constant warfare until well past the first half of the sixteenth century. Nothing in Italy would ever be as it had been, and the peninsula found itself encircled by mounting external threats from countries that saw it as a territory to be conquered and divided up, with only a marginal role in European events—which by then had been extended across the Atlantic to a new continent, discovered, of course, by an Italian. While the great nations of Europe set about their colonial expansion, the minuscule kingdoms of Italy lost their liberty, overrun by waves of French soldiers commanded by Charles VIII, Louis XII, and Francis I, by Germans sent by Maximilian and Spanish sent by Ferdinand

enter a new period in which he would be called on to satisfy the requests of a series of different patrons, each of them anxious to put him to the test.

The first stop was Mantua, the city of the Gonzagas and kingdom of Isabella d'Este, wife of the marquis Francesco Gonzaga and muse of one of the most renowned and sophisticated courts of the

Above: Andrea Mantegna, *The Death of the Virgin* (detail), ca. 1460; Prado, Madrid. In the background of this painting, one of the best known by this Veneto master, appears a view of the city of Mantua, with its lakes created by the Mincio River.

Left: Francesco Granacci, *Charles VIII Enters Florence*, 1515–17; Palazzo Medici-Riccardi, Florence.

II, and finally by the imperial troops of Charles V.

Leonardo had departed Milan in the winter of 1499–1500 with the avowed purpose of reaching Florence, but he made at least two stops along the way. After a long and profitable relationship with a single ruler, Ludovico Sforza, he was about to

Renaissance. She was delighted to welcome him for a few months. Isabella was highly demanding in her taste; ever since seeing Leonardo's portrait of Cecilia Gallerani, she had been longing to have him paint her portrait too. In fact Gallerani, by then Countess Bergamini, was also at the Gonzaga court,

Isabella d'Este

(Ferrara, 1474–Mantua, 1539)

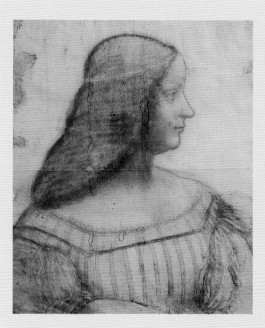

versation. When her husband was held prisoner by the Venetians in 1509, Isabella held the reins of government and proved herself astute at diplomacy; her son Francesco, who became marquis in 1519, found her an invaluable adviser.

She is ranked among the most dedicated collectors of the Renaissance. She decorated the rooms in her palace, most of all her *studiolo (private study)* and the cavelike grotta, *which held her favorite antiquities, with ancient and modern masterpieces, sought out tirelessly and by means of helpful agents. These included works specially commissioned by her from the leading artists of the time, very often made on the basis of her very detailed instructions.*

She was the firstborn daughter of the duke of Ferrara, Ercole d'Este, and Eleonora of Aragon, and her education in humanistic studies began when she was still a child. At sixteen she was married to Francesco Gonzaga, who was to inherit from his father the marquisate of Mantua, and she made his court one of Europe's most prestigious and admired. Patron and friend of artists, men of letters, and musicians, Isabella set the style of the period, based on her personal taste. It is significant that in the portrait Leonardo made of her, she is presented looking at a book (no longer visible because the lower part of the page has been cut away), emblematic of her patronage of writers and her love for antique manuscripts. The fame of her learning and her spirit, along with the fascination of her personality, won her the respect of rulers and ambassadors, drawn to her by her wisdom as much as by her brilliant and delightful con-

Above: Leonardo, *Cartoon for a Portrait of Isabella d'Este,* 1499–1500; Louvre, Paris.

Below: Lorenzo Costa, *Allegory of the Court of Isabella d'Este,* 1506; Louvre, Paris.

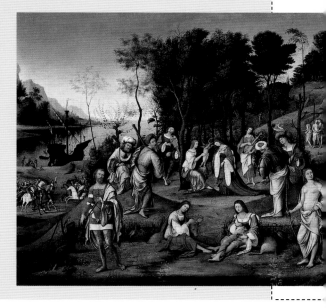

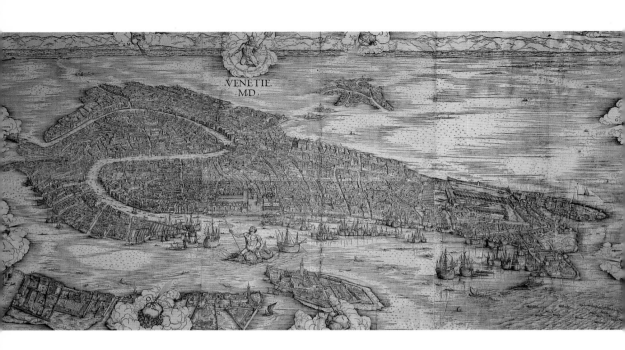

along with other fugitives still loyal to Ludovico (his former mistress Lucrezia Crivelli spent a long time at Mantua). Leonardo left Mantua without making a portrait of the marchesa, although he did depict her in two drawings, one of which is today in the Louvre.

Isabella's continuing efforts to obtain a painting from Leonardo and her insistence on being kept informed of his every action that might pertain to her efforts as a collector led to a series of letters from her agents illuminating Leonardo's movements. The series begins with a letter informing her that on March 13, 1500, Leonardo was in Venice, where he had with him an image of the marchesa, probably the drawing today in the Louvre, which awakened great interest among the new generation of Venetian painters, from Giorgione to Titian.

Despite its brevity, Leonardo's visit to Venice had consequences of vast importance to Venetian painting, thanks primarily to Leonardo's habit of traveling with drawings—in this case preparatory studies for the apostles in *The Last Supper*—and

small compositions—a cross-bearing Christ—and to his willingness to display them. Venice also saw the activity of several Leonardesque painters. It seems that while in Venice Leonardo was not involved in any activities as a painter but served instead as a military adviser for the city, where there were great worries about a possible Turkish invasion. Following the conquest of Constantinople in 1453, the expansion of the Ottoman Empire was seen as the

Leonardo

But when the bird is in the wind it can support itself upon the wind without beating its wings, for the function of wings that move against the air when it is motionless is performed by the air moving against the wings when they are motionless. The bird rises upward along descending air in the manner in which water falls in an empty screw, which rises by constantly falling.

(Codex Atlanticus)

most concrete threat to Venetian predominance in the Mediterranean area (this rivalry had induced Ludovico to incite the Turks against Venice). In 1499, old alliances had been overturned and Venice was now an ally of France, a fact that might explain Leonardo's presence in the city, perhaps sent there by the French to perform a military inspection of the eastern territories of Venice, as indicated by his report on the defense of Friuli against the Turks, sketched out in two letters (Codex Atlanticus), with drawings of the Isonzo River, along the bed of which he imagined a system of defenses composed of angular palisades. Mobile bulkheads would have made it possible to quickly raise or lower the water level, causing sudden flooding of the surrounding area.

There is yet another possible explanation for Leonardo's trip to Venice, one related to Luca Pacioli, who accompanied him there. In 1509 Pacioli was to publish in Venice his *De Divina Proportione*, and this trip may have involved arrangements for the printing. Gutenberg's invention had quickly become widespread, taking root and thriving in particular in Venice, which soon became the main center for the printing of books on humanistic and scientific themes. Indeed, among all the merchandise available on the enormous Venetian marketplace, Leonardo quickly bought several books. Despite his practical concerns, Leonardo cannot have overlooked the enormous quantity of art that the city had to offer, from the equestrian monument of Bartolomeo Colleoni by Verrocchio to the ancient and modern masterpieces in the city's many collections.

At the end of March 1500 Leonardo made it back to Florence, the city that for the next eight years would be, if not his fixed home, at least his most stable point of reference. A period now began

Opposite: Jacopo de' Barbari, *View of Venice*, 1500; Museo Correr, Venice. The map, which is one of the masterpieces of Renaissance cartography, offers a panorama that is also a celebration of the power of Venice, ruler of the seas, surrounded by the winds and protected by Neptune.

Right: Leonardo, *Report on the Defense of Friuli from the Turks*, 1500; Biblioteca Ambrosiana, Milan.

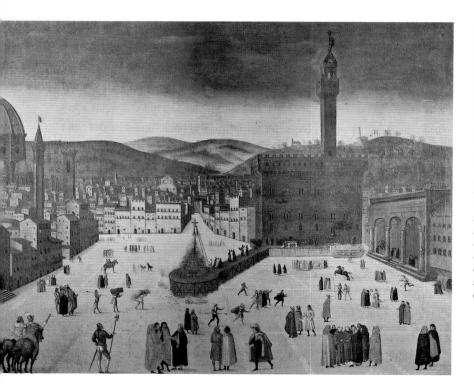

during which he seems to have enjoyed the gift of ubiquity, such are the many places and times where he shows up performing some operation, here as a painter, there as an adviser or consultant, here again as an engineer. Florence was no longer the city he had once known. The age of peace and harmony inaugurated by Lorenzo the Magnificent was over. In 1494, with the arrival of France's Charles VIII, Piero de' Medici had been expelled by the citizens, who then formed a republic that followed the austere rule of the Dominican religious reformer Girolamo Savonarola for four years, before he was declared a heretic by Pope Alexander VI and burned at the stake in 1498. By the early sixteenth century the republican government, selected from a restricted group, had taken on an oligarchic imprint. Leonardo's attitude toward these political upheavals demonstrates that ties to any one place were never of determinant importance to him. He wanted sit-

uations that offered him the opportunity to carry on his tireless activity. He willingly accepted the occasional opportunities that presented themselves to earn money by giving advice on artistic subjects. If he had to travel to do so, he did so.

In August 1500, one of Leonardo's designs for the Florentine villa of Agnolo Tovaglia was sent to Francesco Gonzaga, who wanted to have a similar home built. Leonardo offered to make a painting or model of the proposed building. He continued to work as a consultant for the ruler of Mantua (in 1502, for example, he assessed the value of several vases belonging to Lorenzo the Magnificent that Isabella d'Este intended to buy). He also lent his services to the new leading figures on the political scene in Italy, the epicenter of which had now shifted to Rome.

In the jubilee year 1500, crowds of pilgrims arrived in the capital of Christianity, then ruled by

Alexander VI (Rodrigo Borgia), the pope who had sided with the French, who in turn supported his son Cesare. Louis XII had asked the pope to annul his first marriage so he could marry Anne of Brittany, widow of Charles VIII; in exchange, he had supported Cesare's rise, naming the former cardinal duke of Valentinois. The ruthless, cunning, and cruel Cesare had then set about creating a personal

Cesare Borgia
(Rome, ca. 1475–Viana, 1507)

Son of Cardinal Rodrigo Borgia, pope (1492–1503) as Alexander VI, Cesare was originally destined for an ecclesiastical post. Not yet twenty, he quit his clerical career to replace his older brother—perhaps after having him killed—as captain general and gonfaloniere of the church. He convinced his father to ally with the king of France, Louis XII, who made him duke of Valentinois (for which reason he is also known as Valentino) and offered him the hand of Charlotte d'Albret. He then set about consolidating the Papal States in Romagna and the Marches, letting nothing stop him: he did not hesitate to eliminate anyone, enemy or relative, who stood in his way.

His ruthlessness awakened the admiration of Machiavelli, who made him the hero of his best-known work, The Prince. Cesare was the model of the modern statesman who does not let morality get in the way of the maintenance of power. After his father's death, he failed to hold on to his conquests. Taken prisoner by order of Pope Julius II, he was imprisoned first in Naples and then in Spain. He escaped prison and took shelter with relatives in Navarre, but he no longer enjoyed the favor of Louis XII, who refused to give him exile in France or to give him the duchy of Valentinois. He died on the field of battle, fighting for the king of Navarre. The Borgias thus vanished from the Italian political scene, but as Machiavelli wrote, following the death of Alexander VI and "Valentino," the church "was strengthened by possession of the whole of Romagna, and the Roman barons exhausted and their factions shattered under the blows of Alexander VI."

Above: Cesare Borgia in an engraving by Paolo Giovio, *Elogia Virorum Bellica Virtute Illustrium*, Basel, 1577. Below: Leonardo, *Triple Portrait of Cesare Borgia*, ca. 1502; Biblioteca Reale, Turin.

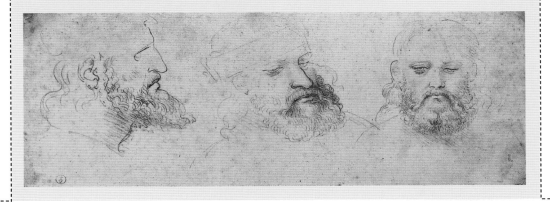

kingdom for himself by subjecting the cities of Romagna and central Italy.

All of Italy, principalities and republics, feared the apparently unstoppable rise of this new star, including Florence, which to hold him at bay sent him money and, to avoid being taken by surprise, sent off Niccolò Machiavelli to keep an eye on his movements. In 1499 Cesare Borgia had been alongside Louis XII when the French king made his triumphal entry into Milan. Leonardo had been on hand to see those two men ride past, side by side. During the first years of the sixteenth century, they were to hold the reins of Italy, and the period of their ascendance would be marked by extreme political unscrupulousness that made use of every means, from betrayal to murder.

In 1500 Holy Roman Emperor Maximilian signed a treaty with France, and Louis XII allied with the rulers of Spain to drive the Aragonese from the throne of Naples and divide the kingdom of southern Italy. Meanwhile, Cesare was taking control of all of Romagna with the exception of Faenza, which put up a fierce resistance led by the eighteen-year-old Lord Astorre Manfredi. Soon Faenza, too, was conquered and added to the subjects of Cesare, who was rapidly transforming the Papal States into the Borgia States, while in Rome the court of Alexander VI made a name for its worldliness, magnificence, and political influ-ence. It was this Spanish pope who, with the 1494 Treaty of Tordesillas, divided the lands of the New World between Spain and Portugal. During the years of the Borgia pontificate (1492–1503), the excesses reached by the worldliness of the church leaders, the relaxation of moral attitudes, the nepotism, and the corruption of the clergy became scandalous and attracted great disapproval. At the same time Rome became a showplace of ancient and modern art, and the pope and papal curia promoted the arts and cultural undertakings.

This is the city Leonardo visited, apparently to deal with the matter indicated in the Ligny Memorandum, thus probably to do something like what he had done in Venice, involving questions of a strategic military nature. Contact with Rome meant contact with the ancient past. From an autograph note we know that on March 10, 1501 (1500

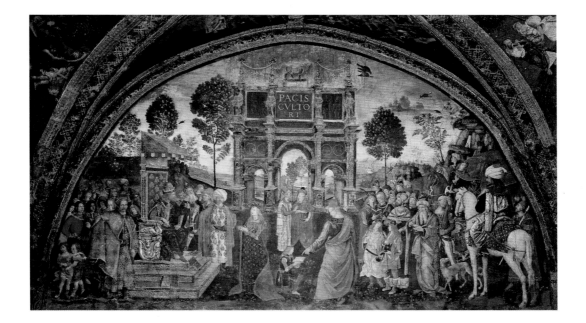

Above: Pinturicchio, *The Disputation of St. Catherine*, 1492–94; Palazzi Vaticani, Rome.

Below: Aerial view of Tivoli with ruins from the Roman period.

according to the Florentine *ab incarnatione* system, that is, with the year beginning on March 25), he was in Tivoli, at the "home of Hadrian." There were plenty of literary and artistic reasons for his wanting to go there.

His never-sated interest in the ancient had been honed and perfected in Milan, where ancient works and texts were studied, compared, and drawn upon for inspiration. The buildings dating to the Roman emperor Hadrian and the elaborate villa he had built at Tivoli were listed among the notable things by authors known to Leonardo, including the recommendation to visit the ruins of Tivoli to see "good architecture."

From then on, the influence of classical art shows up regularly in the works of Leonardo. Precise references have been found to four statues of the Muses, today in the Prado in Madrid, found in the Roman theater of Tivoli during the works commissioned by Alexander VI. The new fullness and monumentality of Leonardo's figures were derived from examples of ancient sculptures.

IN THE SERVICE OF FLORENCE AND CESARE BORGIA

The stay in Rome ended soon; Leonardo was back in Florence by April. A letter of April 3 from Fra Pietro da Novellara to Isabella d'Este, still eager to obtain a painting from Leonardo, preferably a Madonna, contains the description of a small, still unfinished, full-size cartoon on which the master was working, with figures of the Virgin and Child, St. Anne, and a little lamb. This lost cartoon introduces an iconography that Leonardo was to take up and work on again and again, as, for example, in the only surviving cartoon by his hand, *The Virgin and Child with St. Anne and St. John the Baptist*, in the National Gallery, Lon-

PETRVS SODERINI

don, and *The Virgin and Child with St. Anne* in the Louvre.

The frequency with which this subject appears in Leonardo's production from this point on, without any apparent connection to a specific commission, has been interpreted as an effort on his part to adapt to the new political reality in Florence, declaring his republican sympathies. It had been on July 26, the feast day of St. Anne, that the Florentines had arisen against the tyranny of Gualtiero di Brienne in 1343, and the saint had come to assume a special meaning in the iconography of the city. Another image has been related to the new republican order, a *Salvator Mundi*: on the day of San Salvatore in 1494 the Medici had been driven out of Florence. Leonardo made preparatory studies for this *Salvator Mundi* that date from 1510 to 1513, and an anonymous follower who had access to Leonardo's drawings used them to paint a panel.

The list of paintings attributed to the first decade

continued without interruption. Each of these works was innovative, even when dealing with traditional iconography, and each on its appearance was greeted with profound admiration, directed most of all at narrative and compositional qualities.

In a letter slightly after that of April 3, Pietro da Novellara, aside from reassuring Isabella d'Este that Leonardo would paint her portrait as soon as he got free from the work he was doing for the king of France, describes a small painting made for Florimond Robertet, Louis XII's secretary, today lost, but known from a study and various copies. This is the so-called *Madonna with the Yarn-Winder*. To meet a request from Isabella in 1504, Leonardo conceived, without making it, the image of a young Christ, a work that shows up in paintings by his followers.

In the summer of 1502 Leonardo entered the service of Cesare Borgia as a military architect and engineer. In June he went with Cesare to Urbino, formerly a possession of the Montefeltro family that Cesare had taken in one of his "magnificent deceptions." Duke Guidobaldo had been

of the new century, including works that have survived, been lost, or completed by others following Leonardo's ideas, is surprisingly long, even more so if one considers the quantity of responsibilities that were keeping him busy at the same time, along with his dedication to theoretical studies, which he

Opposite top: Anonymous, *Pier Soderini;* Uffizi, Florence.

Opposite bottom: Leonardo, *The Virgin and Child with St. Anne and St. John the Baptist,* ca. 1501–05; National Gallery, London.

Above: Leonardo, *Study for the Bust of a Woman,* ca. 1499–1501; Royal Library, Windsor.

Right: Leonardo, *Bird's-Eye View of the Arno and Western Tuscany,* 1503–04; Royal Library, Windsor.

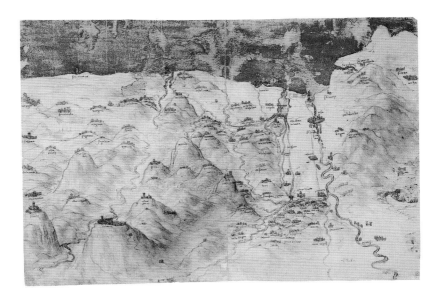

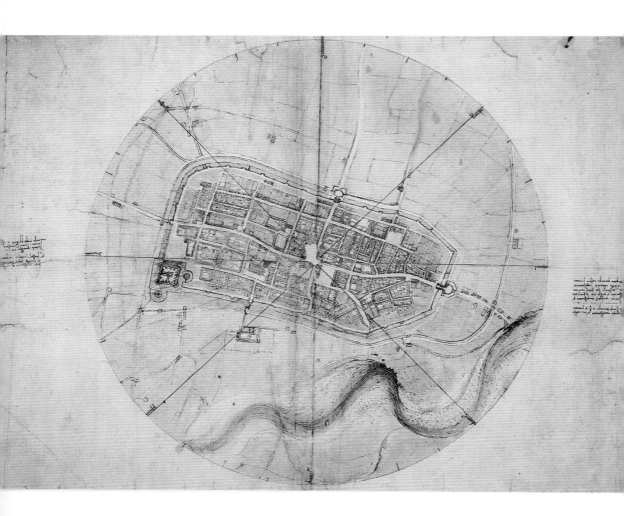

tricked by his advisers into handing over his artillery, which they claimed was needed against the town of Camerino; instead, his own weapons had been turned against him, forcing him to flee with his wife, Elisabetta Gonzaga. The city and the ducal palace, one of the most famous buildings of the Italian Renaissance, full of priceless works of art, had been sacked for several weeks. Among the masterpieces in the palace was the *Urbino Diptych*, the portraits of Federico da Montefeltro and his wife, Battista Sforza, painted by Piero della Francesca against a detailed landscape background. Leonardo was able to see the work and remembered it when he painted the *Mona Lisa*.

On August 18, 1502, Cesare Borgia granted Leonardo permission, as "architect and general engineer," to visit all the fortresses of the Borgia state, to measure and examine anything he wanted, and to carry out operations of improvement as he saw fit, with the promise of as many men as he might request. He had already begun performing such surveys, for on July 30 he was at Urbino, on August 1 at Pesaro, then came Cesena, Cesenatico, Piombino . . .

The itinerary of his period serving Cesare Borgia, which ended early in 1503, is well documented up to the end of October 1502 in a notebook (Codex I). Although there are almost no

indications of the effective results of his activities, they did include measuring the Borgia territory for the purpose of making maps of Tuscany and Romagna. Outstanding among these is the beautiful color map of Imola, a city that fell into Cesare's hands in 1499. This map, judged the most beautiful cartographic document of the Renaissance, was the result of the accurate measuring—Leonardo himself paced off the distances—of roads, squares, and open spaces. The section depicting the city center provides great detail, including all the major buildings and even the rows of porticoes. The buildings are pink, the squares dark yellow, the road white, the countryside is pale yellow, the canals, moats, and Santerno River are blue. This map leads back to the maps and perspective views Leonardo made of Milan and to his ideas for an ideal city, also from the Milan period, which presents the concept of the city as a living organism, animated by the same laws that govern the human body. In Milan, Leonardo had met the person destined to have the most direct and decisive effect on his activity as a military engineer: Francesco di Giorgio Martini, painter, sculptor, and superintendent of buildings in Siena and later military architect and engineer to the duke of Urbino. He was among the first military architects to provide his fortifications—he was famous for having built more than a hundred—with adequate defenses against cannon fire. Leonardo had a copy, given him by the author himself, of Martini's *Treatise on Architecture,*

and he drew on it for many ideas for new weapons.

While traveling across the peninsula overseeing improvements in Borgia's military standing, Leonardo, as was his habit, observed, sketched, and sought to explain every new thing he encountered, thus becoming involved in a myriad of new questions. In Urbino he was struck by a new type of pigeon loft and sketched several architectural elements of the ducal palace; at Cesena he studied ways of transporting grapes and also the framing of windows; in Piombino

Opposite: Map of Imola, 1502; Royal Library, Windsor.

Right: Ducal palace, Urbino. When he went to Urbino as military adviser to Cesare Borgia, Leonardo was fascinated by the architectural structure of the palace and by the magnificent works in its collections.

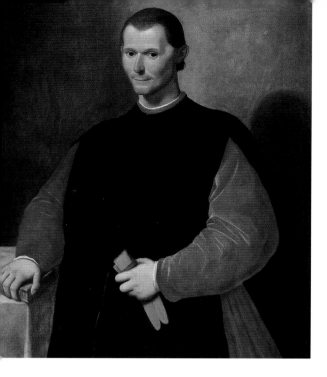

the Golden Horn of the Bosporus. The original-ity of the proposal, never undertaken, consisted primarily in the unusual size of the structure, impossible to make using the techniques of the time.

In the spring of 1503 he was again in Flo-rence, busy with the war against Pisa. The city, a dominion of Florence since 1406, had rebelled in 1494 and since then had been fighting for its independence. The Florentine republic undertook a new expedition that was to include the auda-cious scheme to deviate the course of the Arno River to deprive Pisa of water and cut it off from access to the sea and naval reinforcements. Attempts to create a system of deviations went on for a year; according to Florentine calcula-tions, digging the canals would require 150 to 200 days of labor on the part of 2,000 workers. These calculations were optimistic; according to a later estimate, at least five times as many days of work would have been required. Furthermore, it would have been impossible to assemble—and pay—such a large number of workers. After var-

he studied the formation of waves, in Romagna wheeled vehicles, in Rimini a musical fountain; in Pesaro he visited the library; in Siena he took notes on the functioning of a bell.

To 1502–03 dates a daring architectural pro-ject that Leonardo sent to Bajazet II, sultan of Constantinople: the construction of a bridge over

Above: Santi di Tito, *Portrait of Niccolò Machiavelli* (?), sixteenth century; Uffizi, Florence. The stern gentleman shown here has been traditionally identified as Machiavelli, the great founder of modern political theory, whom Leonardo met in Florence.

Right: Leonardo, *The Val di Chiana*, ca. 1502; Royal Library, Windsor.

Opposite: Leonardo, *Sketch of the Arno River*, 1504; Royal Library, Windsor.

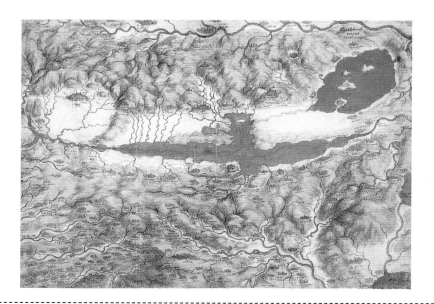

ious fruitless attempts, the idea was abandoned in the fall of 1505. (Pisa finally surrendered in 1509.) One of the most active supporters of the plan had been Niccolò Machiavelli, the admin- of the course of the Arno, dating to the period 1503–05. These were part of another audacious project, but this one peaceful: getting around an unnavigable stretch of the river by con-

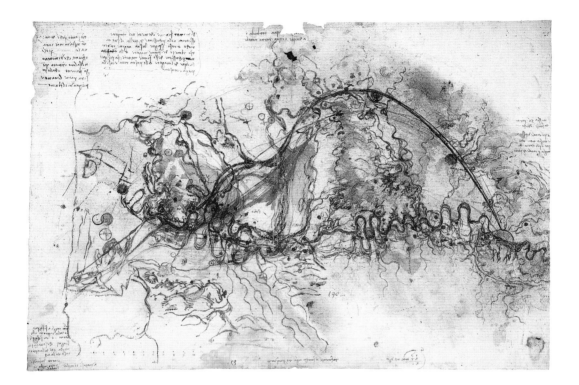

istrator responsible for Florence's military and diplomatic policy, supported by the *gonfaloniere* for life Pier Soderini, the most important figure in the state. Leonardo—who had met Machiavelli during the fall of 1502 when the "Florentine secretary" had been on a diplomatic mission to Cesare Borgia in Romagna, and who in July 1503 had been sent to Florence to inspect the recently begun trench digging—did not have an active role in the plans. His role was limited to expressing his opinion, which was not positive. The experience increased his long-standing fascination with rivers and with the impressive hydraulic works on the Po River and led to a series of maps structing a canal to the north of it with an almost semicircular route. The plan would have required making a tunnel through Mount Serravalle at the precise spot where such a tunnel was to be made more than four hundred years later during the construction of Italy's autostrada. At its exit from Florence, the river would have been diverted to the northwest to reach Prato and Pistoia, overcoming the Apennine streams with bridges and canals and using part of its water to irrigate an arid plain before cutting through Serravalle; it would then have descended to the south to empty into its natural course to the east of Pisa. To maintain a suitable water level for naviga-

tion, Leonardo proposed the creation of an artificial reservoir by flooding the marshes of the Val di Chiana and joining them to Lake Trasimeno.

To make the idea practicable, Leonardo thought up methods to facilitate the transportation of the material dug up. To avoid the use of wheelbarrows, he designed a gigantic ditch-digging machine with buckets hanging from rotating arms. After each bucket was filled, it would be transported back to be emptied, counterbalancing the arriving buckets. To demonstrate the advantages of the plan, Leonardo calculated the profits to be made at Prato, Pistoia, and Florence from the collection of tolls and the use of the water: about two hundred thousand ducats per year. To obtain a more complete notion of the morphology of the territory involved, he drew true "aerial views" of Tuscany. These remain the most important result of the never-carried-out plans for the canal.

In November 1504 he again had the opportunity to design and direct an operation of excavation, although on a far more modest scale. This was related to the strengthening of the fortifi-

Above: Leonardo, *Drawing of a Bastion with Fortified Rings and Floodable Moats;* Biblioteca Ambrosiana, Milan.

Below and opposite: Leonardo, *Map of a Length of the Arno,* 1504; Royal Library, Windsor. Because of its winding course and the variations in its water level, the Arno was not navigable between Florence and Pisa.

the citadel, gates of the city, and other strategic points with a series of trenches, moats, and covered walkways designed to facilitate the flight of the ruler in case of traitors in his camp. He suggested the construction of a circular tower within the citadel, and to increase the artillery's field of fire instructed that several hills be leveled. The only work undertaken during his stay was the construction of a moat running from the citadel to the city's port; but this minor undertaking led to a highly original element of military architecture, the first modern bastion,

cations of Piombino, which had been returned to Jacopo IV d'Appiano after the ascent of Cesare Borgia had come to a sudden end following the death, in 1503, of Alexander VI. After the brief pontificate of Pius III, the tiara passed to Julius II, an implacable enemy of the Borgia family, who had Cesare arrested and demanded the return of the territories he had usurped. For the Florentines, Jacopo d'Appiano represented a useful ally against Pisa and Siena, and to rekindle friendship with him, lost after Cesare Borgia had been selected over him as condottiere of the republic, Machiavelli was sent on a diplomatic mission to him at Piombino in April 1504. In the fall, Leonardo too received instructions to go to Piombino to furnish his assistance. He stayed only about six or seven weeks, but he was already familiar with the area, having visited it while serving Cesare Borgia, and he made use of this knowledge to work out detailed plans for the city's defense while also taking on various other projects. Remembering how the captain of the castle of Milan had betrayed the city and how betrayals had been the undoing of the opponents of Cesare Borgia, Leonardo proposed connecting

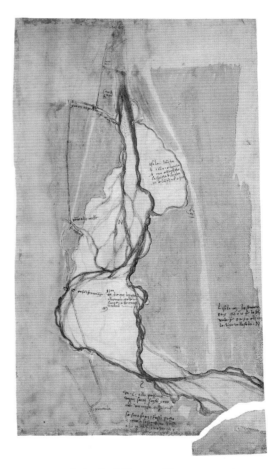

precursor of the buildings of later centuries: a circular fortress composed of three concentric rings for the deployment of the defenders, com-

municating by way of floodable underground tunnels, surrounded by floodable moats, and further defended by four outposts on the outer perimeter.

execution of a monumental painting for the new Sala del Gran Consiglio in Palazzo Vecchio. Designed by Antonio da Sangallo the Elder, the hall had been built only recently, between 1495

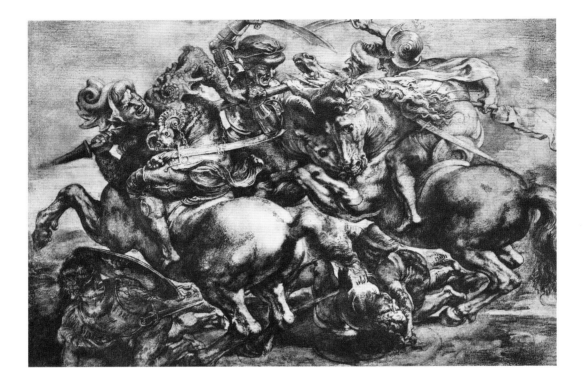

A "GREAT AND NOTABLE" WORK

During this period Leonardo was very highly esteemed by his fellow Florentines. As recorded in the words of Vasari: "The great achievements of this inspired artist so increased his prestige that everyone who loved art, or rather every single person in Florence, was anxious for him to leave the city some memorial; and it was being proposed everywhere that Leonardo should be commissioned to do some great and notable work."

During the same period that he was acting as military adviser to the city, the Florentine government gave him a prestigious commission: the

and 1498, as an addition to the Palazzo della Signoria—a period in 1495 when Leonardo was absent from Milan has been interpreted as a short return to Florence to contribute to this architectural undertaking.

The decoration of the hall, designed to exalt Florence's civic and historical values, called for contributions from many leading artists. Filippino Lippi was to paint an altarpiece dedicated to St. Anne; Andrea Sansovino was charged to sculpt a statue of the Savior to place above the loggia of the *gonfaloniere* and the priors; and Leonardo and Michelangelo were chosen to depict, respectively, the battles of Anghiari, a Florentine victory against

Opposite: Peter Paul Rubens, *The Fight for the Standard* (after Leonardo's *Battle of Anghiari*), ca. 1603; Louvre, Paris.

Right: Modern reconstruction of the central portion of the *Battle of Anghiari,* based on Leonardo's drawings.

the Milanese in 1440, and Cascina, which ended with the defeat of the hated Pisan enemies in the distant 1364. None of these works was ever completed, and of those left unfinished only one survives, the altarpiece of St. Anne, entrusted to Fra Bartolomeo in 1510, six years after the death of Filippino Lippi. No contract related to the two battles has survived, but other documents attest that in October 1503 Leonardo was given the keys to the Sala del Papa and to the contiguous rooms in Santa Maria Novella, where he had room to make full-size cartoons. The historical episode he had been asked to represent was the flight of Niccolò Piccinino, commander of the troops of Filippo Maria Visconti, defeated by the allied Florentine and papal troops. In December and the early months of 1504 he drew on accounts for the purchase of materials and for the work he had by then made. In May, perhaps due to his habitual lateness, a new contract was drawn up that set February 1505 for the completion of the cartoon or at least for the application to the wall of the part of the composition until then designed on cartoons. During the summer a mobile scaffolding was built in the Sala del Gran Consiglio, and at the end of August Leonardo received the necessary materials to prepare the wall. After a break in November (the weeks he spent at Piombino), the work went ahead and continued despite the onset of winter. To protect Leonardo and Michelangelo—who by then was working on the history painting on the adjacent wall—from the cold, the windows were sealed over with waxed canvas.

In January 1504 Leonardo was called on to give his opinion of the best placement of Michelangelo's *David,* after which he began competing with his colleague, who enjoyed an excellent reputation. Leonardo's notes critical of painters who "make their nudes wooden and without grace, so that they seem to look like a sack of nuts" because of the excessive bulk given muscle, which appear in several of his notebooks as a warning to himself, may have been suggested to him by the nudes in the cartoon that Michelangelo was making.

In February 1505 Leonardo, who by then had the help of several assistants,

Michelangelo, *David,* 1501–04; Gallerie dell'Accademia, Florence.

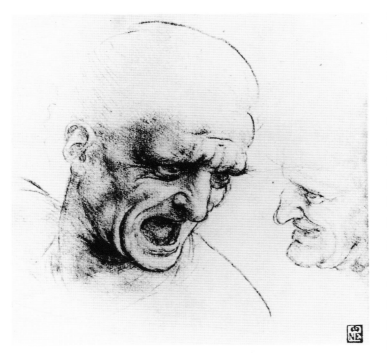

mixing the paints with linseed oil and then drying them by means of a fire lit at the bottom of the wall, worked well on a small-size test panel, as is known thanks to copies and to an engraving datable to 1558. Unfortunately, the procedure was not successful, for the stucco crumbled, ruining the wall and the applied paint.

Some sources claim it was his disappointment at the poor results that made Leonardo abandon work on the painting; it seems more likely that the decision was not of his own making and depended on the rank of the person who now demanded his presence in Milan.

was still busy on the preparation of the surface destined to receive the paint. The cartoon was probably not yet complete when he began transferring the main parts to the wall, those presenting the battle for the standard. A note in the Madrid Codex II indicates that by the first days of June 1505 the painting phase had begun: "On June 6, 1505, a Friday, on the stroke of the thirteenth hour, I began to paint in the palace. At the very moment of laying down the brush . . . the weather broke and the rain poured until evening." The text continues with a description of a violent storm—the exceptional nature of which induced Leonardo to write down the date, day, and hour—and also indicates that he had been working in the Sala Grande for some time. In order to make it easier to apply the paint slowly and to make possible reworkings and changes, Leonardo adopted an experimental technique using oils on a wall prepared in stucco. This technique, which called for

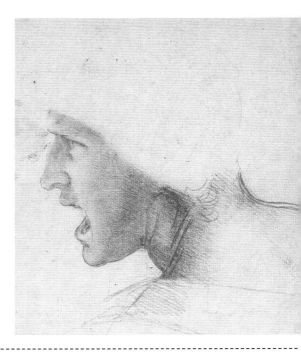

When Leonardo set off for Milan in May 1506, he planned to return within three months. His absence proved far longer, and *Battle of Anghiari* remained unfinished. Michelangelo's *Battle of Cascina* met a similar fate. The two scenes, however, were put on display and became (in the words of Benvenuto Cellini) "the school of the world," greatly affecting the painters who had the opportunity to see them and, most of all, the cartoons (Michelangelo's was destroyed during the arrival of the French in 1512). What was left of Leonardo's work on the wall in Palazzo Vecchio was plastered over when Vasari reworked the room in the 1660s. On the basis of the many copies made of it and of the drawings Leonardo made for it, attempts have been made to reconstruct *Battle of Anghiari* and its central episode of the ferocious battle of four horsemen for the standard, but it is difficult to imagine what the final painting would have been like: a masterpiece that was to cover a space roughly twenty-two by sixty feet. Although the subject of the work was to follow precise instructions from the patrons, Leonardo's inventive fantasy had been given free rein and had taken into consideration a series of motifs that would have presented the "bestial folly" that was for him war. The complete work would have assembled the dynamism of the individual parts to form a turbulent mass, as indicated in the surviving drawings that reveal his thinking on the subject. At paragraph 145 of *Treatise on Painting,* he discusses "how to represent a battle," covering both groups of men, such as "the reserves poised full of hope and fear, their eyes sharpened and shaded with their hands as they survey the dense and murky chaos," and individuals, such as the "conquered and beaten," who should be shown "pale, with their brows knit high and the skin above heavily furrowed with pain." His studies of faces reveal the spiritual element that is behind human actions and that Leonardo created by drawing on his vast knowledge of nature.

Opposite top: Leonardo, *Study of the Heads of Warriors,* ca. 1503–04; Szémüvészeti Múzeum, Budapest.

Opposite bottom: *Study of the Head of a Warrior,* ca. 1503–04; Szémüvészeti Múzeum, Budapest.

Right: Sala dei Cinquecento in Palazzo Vecchio, Florence.

The Last Works for the Florentine Republic

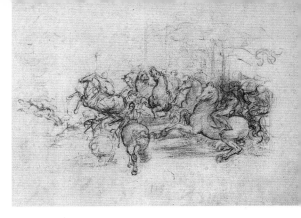

The exaggerated, furiously animated expressions on the faces of the warriors finds its opposite in the imperceptible smile in Leonardo's most famous painting, the portrait known as the *Mona Lisa,* which was conceived during this same period, around 1503 to 1506, but was completed in the next decade.

No documents exist regarding the patronage of the work or any payments made for it. If, as tradition has it, the woman is Lisa de Gherardini, wife of Francesco Bartolomeo del Giocondo, a rich silk merchant connected to the republican government of Florence, the work was made in Tuscany. Stylistic factors based on the landscape suggest that the work dates to around 1510 to 1515, by which time Leonardo was far from the city of his birth.

Among the other projects thought to have originated in the Florentine setting are the two drawings of *Leda and the Swan,* made around 1504 to 1508, one of which Leonardo used to make a painting that is known from drawings and copies made by his followers; the drawing with Neptune made for his friend Antonio Segni in 1504–05; and a painting of Bacchus that the duke of Ferrara tried to acquire. While he was busy with these, Leonardo was also carrying on his theoretical studies, as usual directed at a variety of disciplines. From Pietro da Novellara

we know that in 1504 his attention was concentrated on geometry. As in Milan, he was aided in his exploration of this field by his friend Luca Pacioli, who was in Pisa between 1500 and 1505, teaching at the university. The rules of mathematics were of overwhelming importance to Leonardo: arithmetic and geometry "embrace everything in the universe," he wrote, and "if one

the pretexts for the creation of increasingly new configurations of regular bodies. In the "Treatise on Geometry" (Codex Forster I), begun on July 12, 1505, he explains how to transform geometric bodies without changing their volume. The Codex "On the Flight of Birds," dating to a few months earlier, is considered its opposite number in the field of natural science. He spent hours and

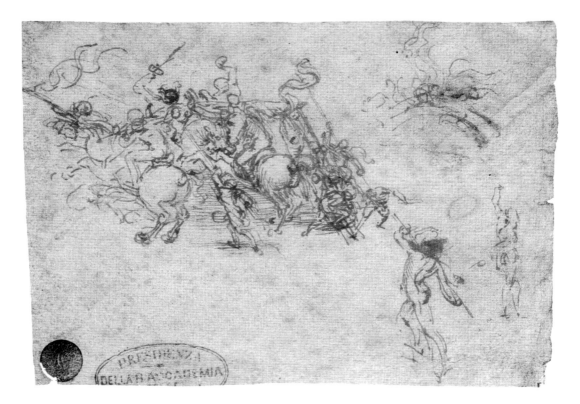

of them is missing nothing can be accomplished" (Codex Madrid II). For a mind like his, capable of giving solid form to abstract intuitions, form and volumes, perceived as tangible realities, became

hours contemplating the mechanism that makes possible the flight of birds and built a "flying machine" similar to a large raptor, which he hoped to launch from a hill near Fiesole. The dynamic of flight forced him to take into consideration a great number of forces, such as air resistance, wind currents, and whirlwinds.

With its wonderful daring, the device is looked upon as one of Leonardo's most fascinating inventions.

Opposite top: Leonardo, *Cavalcade*, ca. 1503–04; Royal Library, Windsor.

Opposite bottom: Leonardo, *Study for a Palace and a Figure of Neptune*, ca. 1506–09; Royal Library, Windsor.

Above: Leonardo, *Battle for the Standard Near the Bridge and Two Foot Soldiers*, ca. 1503; Accademia, Venice.

The *Mona Lisa*

The portrait of Mona Lisa del Giocondo, painted in oil on a panel measuring 30 x 20⅝ in., is not only the most famous work by Leonardo but also the most famous female face in the world. It has inspired scholars, writers, and poets of every age. There is no certainty concerning the young woman's identity; the hypothesis that she is Lisa Gherardini, born in 1479 and married

to Francesco del Giocondo in 1495, is only one of many that have been advanced and is supported most of all by tradition. To reconcile the dating of 1503–04, based on the style, with the divergent indications found in contemporary sources, the theory has been advanced that Leonardo began the painting in Florence (where Raphael made a drawing of it) and, not having completed it, did not give it to the person who had commissioned it but instead completed it in Rome for Giuliano de' Medici, who wanted a work by him regardless of subject. Following Giuliano's death and Leonardo's departure for

...rance, the panel made its way to his studio in Cloux, where Francis I bought it for 4,000 gold crowns.

This woman looking down from a seat on a loggia (the columns originally to either side of her were cut off but are visible in early copies) represents the hinge of the artistic revolution begun by Leonardo, which consisted in bursting free of the limits until then imposed on art. The rules called for the depiction of motionless forms circumscribed in the immutable space and time of perspective; Leonardo broke with this to open art to a new dimension, full of flexible movement and variation. He achieved this through the technique of sfumato brought to extreme perfection, applying coats of transparent, almost liquid paint to a drawing already shaded in chiaroscuro but without sharp outlines, thus building up the gradations of tonality to achieve the elusive landscape with its luministic vibrations. This fluid material, to which Leonardo dedicated much scientific study, became "substance" on the brush and, when applied, left no traces of pictorial texture on the surface. In the background, presented in the usual "aerial perspective," the sinuous river, rocky peaks, and twisting road seem to open and then close, approach and recede, thus participating in the ambiguous mobility of the woman's face. The transformations caused by time on physical reality also take place in the life of the spirit, therefore in psychic reality, and the *Mona Lisa*, with her questioning gaze and most of all her elusive smile,

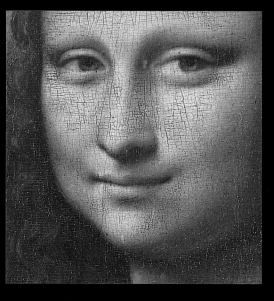

Opposite and left: Leonardo, *Mona Lisa* (whole and detail), 1503–06 and 1510–15; Louvre, Paris.

Above: Follower of Leonardo, *Nude Woman*, first half of sixteenth century; Hermitage, St. Petersburg. This is only one of innumerable works based on the *Mona Lisa*.

suspended between gaiety and melancholy, is the outstanding example of how the motions of the soul can be expressed.

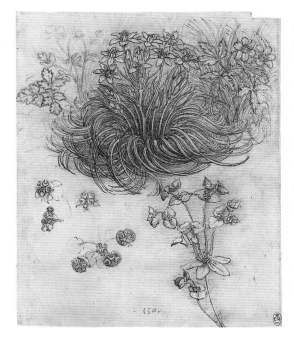

of the books that I leave in the chest" can be taken as an indication that Leonardo knew he was about to leave—the dealings with the French must have been going on for a while—and that he meant to return.

When he began his trip to Milan, he believed he would be back to complete *Battle of Anghiari* within three months, the penalty being the payment of 150 gold florins. By the middle of the third month, Charles d'Amboise, governor of Milan, and Giaffredo Caroli, vice-chancellor, asked the Signoria of Florence to extend his stay one month, which was conceded on August 28. Indignant at Leonardo's failure to finish the painting, Pier Soderini wrote to Amboise, demanding that

In 1505 Leonardo was fifty-three years old and had reached the apex of his fame; he was free from the services of a courtier and could dedicate himself to study and meditation. On a page of the Madrid Codex II we find a list of the books he owned, drawn up immediately before the above-mentioned note of June 6, which gives an idea of the sources of his wide-ranging knowledge. The list includes 116 titles, a notable number for the period, and they include, in almost equal parts, works on science (fifty-one), which in the conception of the period included books on astrology, and general literature (fifty-five), with texts in both Italian and Latin, dealing with history, grammar, dictionaries, and moral works. Books on the arts, including those military, form a minority. A dozen years earlier, Leonardo had drawn up a similar list, composed of forty titles, thirty of which were still present in 1505. The list reveals the already well-known eclecticism of his theoretical training: he was not an erudite scholar but an artist interested in every subject. This "record

Leonardo return since he had "received a large sum of money and had only made a small beginning of the great work." It was in vain. On December 16, Amboise renewed his request to keep Leonardo longer, and the following year the request was repeated by Louis XII in person.

In 1504, with the Treaty of Blois, drawn up with Emperor Maximilian I and his son Philip the Handsome, duke of Burgundy, Louis XII had received the investiture of the duchy of Milan for himself and his male descendants. Philip's son Charles (later Emperor Charles V) had been engaged to Louis's daughter Claude, but this was later annulled. The next year Louis XII had been forced to cede his rights to the kingdom of Naples

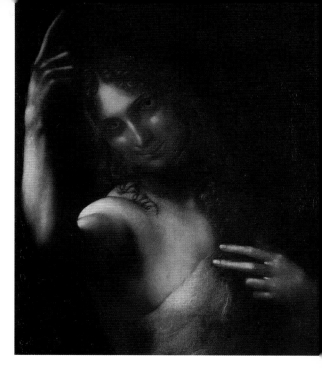

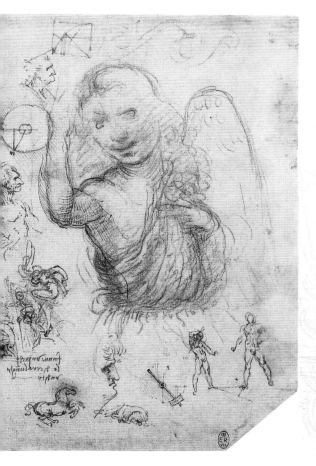

to the king of Aragon, Ferdinand II, who already ruled Sicily and Sardinia and who set himself up in Naples in 1503 after having routed the French army near the Garigliano River. In the contest between France and Spain over which would rule Europe, Milan was an important playing piece.

Soderini's protest meant little compared to the will of the French. Informed that the king was preparing to go to Milan and that he wanted to commission Leonardo to make several paintings, including perhaps his own portrait, the priors of the Signoria could only declare that they would be happy if the artist put himself at the disposition of the king. Thus in 1507 Leonardo was still in Milan. He did manage to make a brief trip to Florence in the spring, and he returned again in

Opposite top: Leonardo, *Star-of-Bethlehem and Other Plants*, ca. 1505–07; Royal Library, Windsor.

Left: Leonardo, *Angel of the Annunciation and Sketches*, ca. 1503–04; Royal Library, Windsor.

Above: Follower of Leonardo, *Angel of the Annunciation*, early sixteenth century; Hermitage, St. Petersburg.

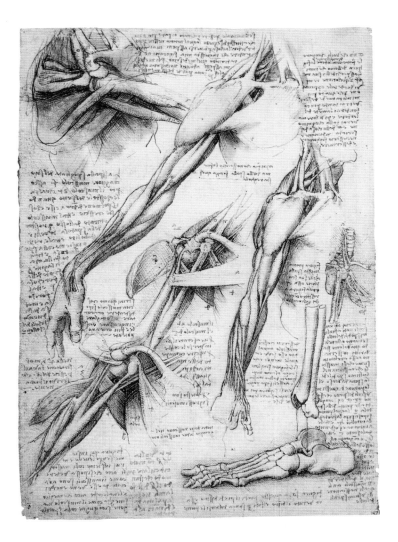

The activity that kept him occupied during these months was not directly related to genres of art, although it had wonderful effects on his painting. Leonardo was always enormously interested in anatomy, seeing it as the key to the precise depiction of the "motions of the soul," and he studied it at every opportunity. He left a report of a complete dissection, carried out on the body of an elderly man who had died a few hours earlier of a natural death in the hospital of Santa Maria Novella in Florence. Leonardo had performed the autopsy "to see the cause of such a sweet death," arriving at a diagnosis of heart failure. This is followed by a description of the state of the heart, blood vessels, and liver, and their influence on the color and loss of tonicity of the elderly man's skin. Leonardo amplified this analysis of the circulatory system to form a comprehensive study of the "irrigation systems" of the human body—urogenital, digestive, nervous, and respiratory—which, according to Leonardo, transport within the body all the substances necessary for life, following the same hydrodynamic laws found in water courses.

August, this time staying ten months. During this period he lived in a house owned by Piero di Baccio Martelli, along with the sculptor Gian Francesco Rustici. According to Vasari, Leonardo assisted Rustici in the modeling of "three bronze figures over the north door" of the baptistery of Florence, and a drawing from the Codex Atlanticus, today in the Royal Library at Windsor, made by a student of Leonardo and corrected by him in pen, presents an angel with its arm raised to indicate the sky, the same gesture as in Rustici's *St. John Preaching between a Levite and a Pharisee,* also over the north door.

He continued to relate his vision of the human body, inspected in increasingly detailed and close-

up views, to a larger system of natural correspondents. To illustrate this he drew complex ramifications, including a "tree of veins" and a "tree of all the nerves," and established an improbable analogy between the human organism and plants. His intention was to create images representing all the vital organs enclosed within the outlines of a transparent body. Despite the impossibility of obtaining scientifically accurate or clearly legible depictions in this way, his drawings of internal organs are of great interest. Between 1506 and 1509 he also studied the "body of the earth," which "like the bodies of animals is woven of branching veins . . . nothing grows in a spot where there is neither sentient, fibrous, nor rational life . . . The grass grows in the fields, the leaves upon the trees, and every year these are renewed in part . . . So we may say that the earth has a spirit of growth, and that its flesh is the soil. Its bones are the successive strata of the rocks that form the mountains; its cartilage is the tufa stone; its blood the veins of its waters. The lake of blood that lies around the heart is the ocean-sea. Its breathing is by the increase and decrease of the blood in its pulses, and even so in the earth is the ebb and flow of the sea" (Codex Leicester). Despite superficial discrepancies, there are profound affinities between the mechanisms of a human and those of the earth. The intimate connection between humans and nature, between micro- and macrocosm, with the same energies flowing through their interiors, appears in Leonardo's paintings, and one cannot help but think of the landscape in perennial transformation in the *Mona Lisa* and the lost *Leda,* a symbol of the generative force of nature.

Opposite: Leonardo, *Anatomy of the Arm, Shoulder, and Foot,* ca. 1510–11; Royal Library, Windsor.

Left: Leonardo, *Anatomy of the Throat and Foot,* 1510–11; Royal Collection, Windsor.

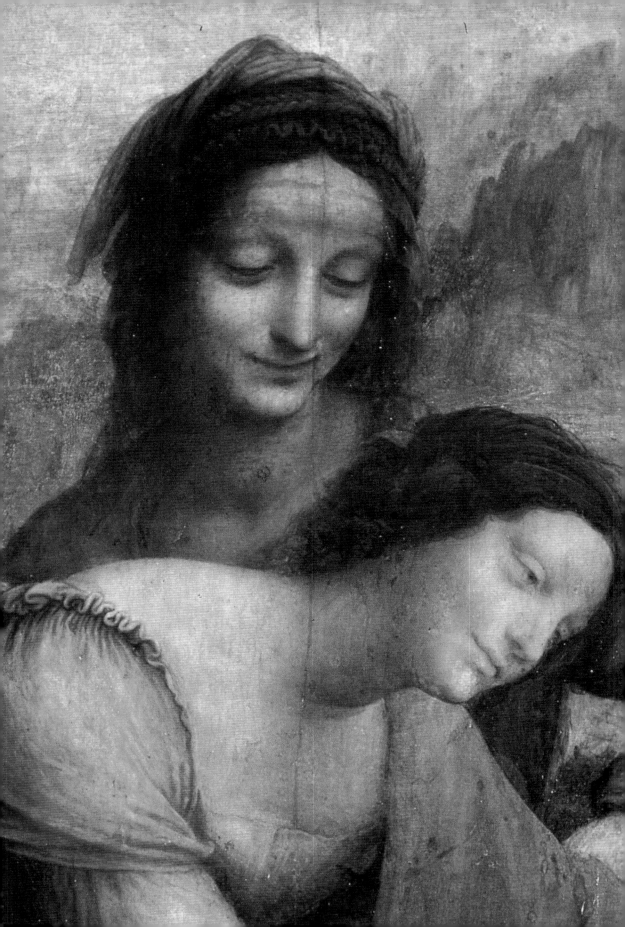

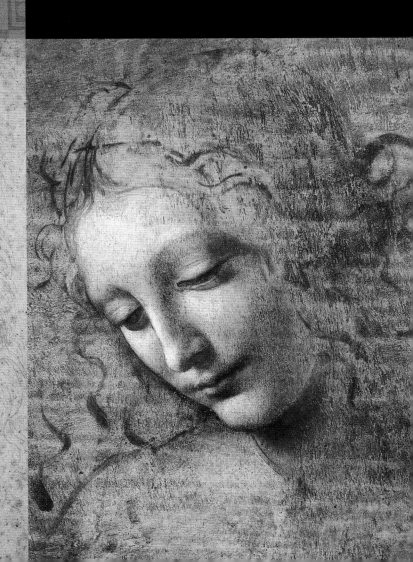

1508–1519
Maestro
Leonardo
da Vinci

The French rulers of Italy
recognize the genius of Leonardo and
welcome him to their homeland.

In Milan Under the French

The last period of Leonardo's career, like all those before it, involved mobility. From 1508 to 1516 his residence was in Milan, but his activities continued without letup, taking him to various Italian cities where he made recorded stays, some brief, others long, to finally arrive in 1516 in France, where despite the increasing infirmities of old age, Leonardo conducted a life that was anything but sedentary.

In September 1508, finally free of all obligations to the republic of Florence, he was in Milan. The financial disputes and difficulties related to his possessions that had resulted from his working alternately for the Florentine republic and for the French had been resolved. The king of France, who named him his *peintre et ingénieur ordinaire,* had the property in San Vittore that Ludovico Sforza had given him restored to him and helped resolve the disputes between Leonardo and his half-brothers that had arisen following the death of Ser Piero. Another pending suit, that concerning the second version of *The Virgin of the Rocks,* brought back to life in 1506 by Ambrogio de' Predis, perhaps acting on behalf of Leonardo, seems to have reached a settlement on August 18, 1508, with both Leonardo and Ambrogio declaring they had no claim to make against the Confraternity of the Immaculate

Left and opposite:
Leonardo, *The Virgin of the Rocks,* second version (whole and detail), 1495–1508, National Gallery, London.

Conception. Leonardo accepted the proposal to complete the central panel of the altarpiece, and the confraternity agreed to pay a sum larger than the amount stipulated, granting him permission to remove the work from the altar for the period necessary to make a copy—a work whose destination is unknown. It may have been lost, but perhaps it was never made.

Leonardo remained in Milan and Lombardy until 1513, dividing his time, as was his habit, among his innumerable interests. The great variety of these can make them seem unrelated, but in reality they were integral parts of an organic system of thought, within which ideas arose from both old and new stimuli. Ideas he had been thinking of over many years would eventually move from the embryonic stage to take bud and give fruit.

The reality in which he was working was profoundly different from that of the court of Ludovico Sforza. With the collapse of Sforza rule, with its legacy of ancient feudal traditions, Milan found itself under the control of a modern national monarchy that was moving toward becoming the strongest and most prosperous in Europe, its power based on an efficient centralized government. In his *Report*

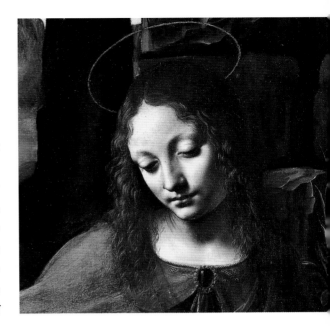

Leonardo

I conclude that in oldest times salt waters entirely occupied and covered the earth, and the mountains, skeleton of the earth with their wide bases, penetrated and arose into the air, covered and decked with abundant, deep soil. Since then great rains, enlarging the streams, despoiled with their frequent lavings the high peaks of those mountains, leaving stone in place of soil.
(Codex Atlanticus)

on the Affairs of France, a brief essay written between 1510 and 1513, Niccolò Machiavelli, who was quite familiar with France, having visited it many times on diplomatic missions, stated that "the crown and king of France are today the most vigorous, rich, and powerful that ever were." France's attempts to make itself the ruler of Italy were opposed, with alternating fortune, by the Holy Roman Empire, Spain, the Swiss Confederation, and Venice. The fate of the duchy of Milan hinged on those contests.

The proposals for city layouts on a page of the Codex Atlanticus probably date to the period of French rule in Milan. The drawings present ideas for the construction of residential buildings with six homes each ("five thousand houses with thirty thousand habitations"). The mature and realistic approach to the problems of city life—which some ascribe to his contact with Machiavelli—suggests that the text dates to the first decade of the sixteenth century rather than to the period he spent in the service of the Sforzas, when he had applied his

In 1506, Charles d'Amboise, duke of Chaumont and governor of Milan, hoping to keep Leonardo in Milan, wrote to the Signoria in Florence: "The excellent works accomplished in Italy and especially in Milan by Maestro Leonardo da Vinci, your fellow citizen, have made all those who see them singularly love their author, even if they have never met him . . . For ourselves, we confess that we loved him before meeting him personally. But now that we have been in his company and can speak from experience of his varied talents, we see in truth that his name, already famous for painting, remains comparatively unknown when one thinks of the praises he merits for the other gifts he possesses, which are of extraordinary power." Charles d'Amboise had personal experience of Leonardo's many abilities because he had commissioned a painting from him as well as the plan for a vast residence with a park and gardens that was to be built in Milan near the church of San Babila. The Codex Atlanticus contains drawings and descriptions of possible versions of the home of the "Gran Maestro." The building is centered on a large room

imagination to a project for building an entire city on several different levels. Putting aside any questions concerning their exact dates, Leonardo's many drawings of homes, churches, palaces, villas, castles, and royal residences display characteristics of modernity and functionality: for him buildings had to be vast and airy, public spaces had to open onto large squares and broad streets and be crossed by water, canals for both transportation and sewage. In keeping with his studies of the natural world, he understood the city as an organism composed of living elements in movement. To be suitable to the life of the land and to the needs of humans, the structures of the city had to correspond to those of the human organism.

flanked by two doors on the longer sides and is set in a garden with orange trees and cedars, a place of delights crossed by flowing streams whose movement is regulated by a mill that produces sounds. Fountains, water displays, flowers, birds, and music were to create an atmosphere of continuous delight.

Datable to a short time later, 1506–07, are the drawings for the funeral monument commissioned by Marshal Gian Giacomo Trivulzio. Trivulzio had left the Milan court because

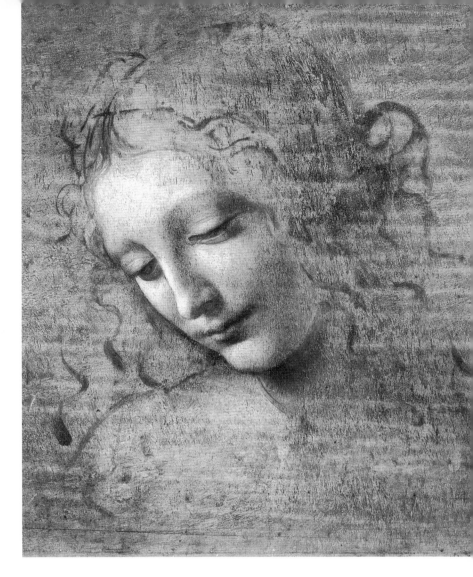

Opposite top: Andrea Solario, *Charles d'Amboise*, 1507–10; Louvre, Paris. Also attributed to another of Leonardo's followers, Cesare da Sesto, this painting clearly shows the influence of the *Mona Lisa*. In striking contrast to the dictates of official portraiture, the face of the governor of Milan seems to reveal emotion, as though he were about to smile.

Opposite bottom: Anonymous sixteenth-century artist, *Portrait of Louis XII;* Uffizi, Florence. An example of official portraiture.

Right: Leonardo, *Head of Girl,* ca. 1508; Pinacoteca Nazionale, Parma.

of the hostility of Ludovico, gone into the service of the Aragonese of Naples, and in 1499 had conquered Milan, taken Ludovico prisoner, and brought him to Novara to Louis XII, receiving in return the nomination of marshal of France. For this work, Leonardo conceived a tall marble platform as support for the equestrian statue, composed of a rearing horse and rider trampling a defeated foe.

The statue, which was to be located in Trivulzio's funeral chapel in the church of San Celso, remained at the drawing stage, but Leonardo's ideas for the monument were taken up by other artists. During

this period the genre of the funeral monument was evolving, and the forms of such monuments that became popular later in the sixteenth century show a close affinity to the type of statue Leonardo planned to build.

In January 1507, King Louis XII expressly requested the services of Leonardo, saying he wished to have him make "certain small panels of Our Lady and other things as the fancy shall take me; and perhaps I shall also cause him to make my own portrait." After doing everything in his power to facilitate the move, he got his wishes. In 1508

Leonardo was given a house in Milan near the Porta Orientale, in the parish of San Babila, and from July 1508 to April 1509 he received regular payments from the king, for whom he began work on two Madonnas that pleased his illustrious patron but of which all trace has been lost. More tangible, although less clear in terms of the circumstances of its execution, is the stupendous *Head of a Girl* in the Pinacoteca Nazionale of Parma. On the basis of its style, this sweetly meditative face has been dated to around 1508 and has been associated with one of the two Madonnas for Louis XII or with the requests in 1501 from Isabella d'Este, who hoped for "a painting of the Madonna as devout and sweet as is her nature." The sweetness, which Leonardo rendered like no other artist, reached its peak in this simple monochrome panel— umber, green amber, and lead white—in which sfumato shading and the gentle passage of light

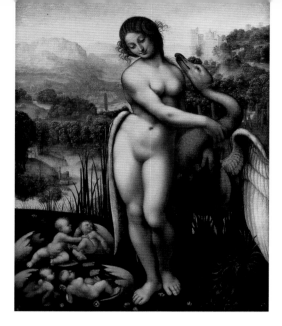

Above: Cesare da Sesto, *Leda and the Swan;* Pembroke Collection, Wilton House, Salisbury.

Below: Leonardo, *Head of Leda,* 1505–07; Royal Library, Windsor.

Opposite top: Leonardo, *Bacchus-St. John the Baptist,* 1510–15; Louvre, Paris.

Opposite bottom: Leonardo, *St. John the Baptist,* 1508–13; Louvre, Paris.

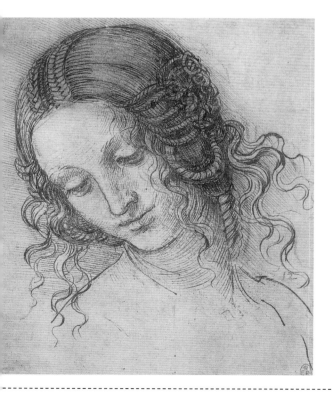

through the shadows make the girl's lips seem to move in an imperceptible smile. Perhaps the discerning Isabella, so keenly aware of the special characteristics of Leonardo's painting, was finally satisfied. The inventory of the art objects of the Gonzaga put on sale in 1627 indicates that the panel was then located in a hall near the *studiolo* and *grotta* of Isabella d'Este, and a tie to the marchesa shows up in a document of 1531, according to which a painting by Leonardo was hanging in the apartment of Margherita Paleologa, bride of Isabella's son, the marquis Federico Gonzaga.

The same soft tonalities of the *Head of a Girl* form the relief of the *St. John the Baptist* standing out against the dark background, today in the Louvre and datable to around 1508–13, which Leonardo brought with him to France. The pose of the saint—his body twisting and presented three-

quarters, his right arm raised, hand pointing upward, and head tilted to the right—is based on that of an *Angel of the Annunciation* that Leonardo had made in Florence. Today lost, this work was cited by Vasari in the collection of Cosimo I de' Medici and is known through many workshop replicas, including the version in the Royal Library, Windsor (page 107). The youthful figures of St. John and the angel, which share the gesture of the raised hand alluding to a divine message to communicate to the earth, are images that, like the *Leda,* the woman-swan, or the *Medusa,* the woman-monster—mentioned by Vasari and by the Anonimo Gaddiano in the palace of Cosimo I—and also like the angel-sphinx of *The Virgin of the Rocks,* were to take hold of many of the followers of Leonardo for their iconography of hybrid beings. The taste for copies of Leonardo's works, made by direct students or by admirers in general, consol-

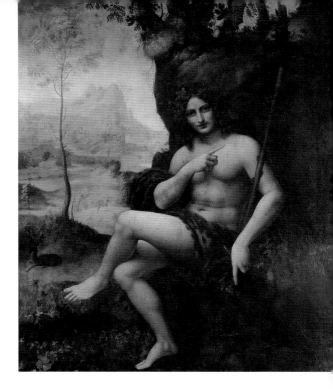

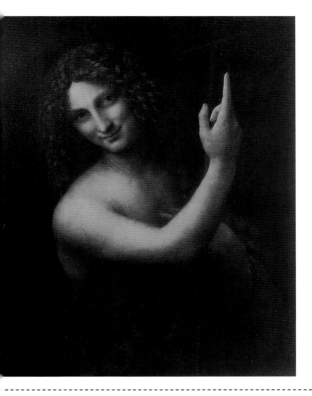

idated the assimilation of Leonardo's style in Lombardy and becomes particularly noticeable in the genre of the portrait. The names of some students (Cesare da Sesto and Bernazzano, Marco d'Oggiono and Francesco Melzi) have been invoked, as collaborators if not as individual executors, for a large canvas transferred to panel, from around 1510 to 1515, of *Bacchus,* today in the Louvre. The attribution of the work and even its original form were put in doubt when it was established that the pagan god is the result of repainting carried out at the end of the seventeenth century, at which time vine leaves and the panther skin were added to an underlying *St. John in the Desert,* a work that had itself been repeatedly copied in the early sixteenth century.

 The last of the works attributed to Leonardo's second stay in Milan is the panel with *The Virgin and Child and St. Anne,* the final version of a theme Leonardo had worked on earlier and in all likelihood the last work of his career as a painter.

The Virgin and Child with St. Anne

The idea for a group composed of the Virgin and Child and St. Anne, along with a young St. John the Baptist or a lamb or with both seems to have occupied Leonardo several times during the last twenty years of his life and led to at least four full-size versions: three cartoons and a painting. Two of these works are in collections today, the cartoon in the National Gallery of London, usually dated to 1501–08 (55⅛ x 40½ in.), and the panel in the Louvre, from circa 1513–15 (65½ x 50¼ in.). The first has the young St. John the Baptist, the second has the lamb.

The chronology of the various

versions, as established by letters and descriptions as well as by copies, is unclear, nor have any contemporary documents related to a particular project survived. In all likelihood the London cartoon was Leonardo's first attempt to give form to the composition, and the panel in Paris was his last. The theme was popular in Florentine iconography, and contemporary sources relate that Leonardo made two cartoons of this subject in Florence, one in the fall of 1500, another in the spring of 1501; both are lost but were among his most admired works. One might be

the version Piero da Novellara described to Isabella d'Este in which the Child was leaning forward and almost slipping off his mother's lap to grab a little lamb, symbolic of his future sacrifice, while the Virgin sought to hold on to him as though to prevent the realization of his destiny, but was in turn held back by St. Anne, symbol of the church. Vasari describes another version, which included both St.

John the Baptist and the lamb. Leonardo's reworking of the subject may be related to a commission he received while still in Milan from Louis XII, who in 1499 married Anne of Brittany.

A little later, Francis I may have entrusted to Leonardo the completion of that work or the execution of a new painting, which became the painting in the Louvre and was in Leonardo's studio at Cloux in 1517. Brought to Italy by Melzi, it was later acquired by Cardinal Richelieu, who gave it to Louis XIII.

Leonardo achieved a dynamic effect in the Louvre work by loosening the classically inspired monumental arrangement presented in the London cartoon; the figures are no longer united in a single complex group,

and Mary leans far to one side, her movement balanced by the firm pose of St. Anne. The attribution to Leonardo is supported by beautiful autograph drawings and by copies of drawings by Leonardo. The distant landscape is related to his geological studies, and the stratification of the rocks, evanescent atmosphere and aerial perspective are unmistakably by Leonardo

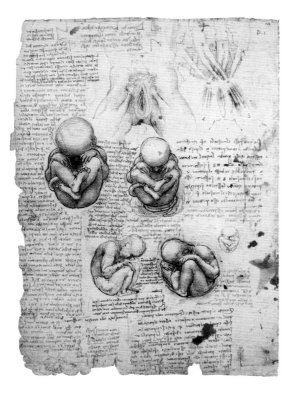

Into this work he poured his deep meditations on three fundamental scientific subjects: the movement of water, geology, and anatomy.

Probably as early as the 1580s, Leonardo had been seeking a "way to walk on water" and since then had gradually passed from the practical and mechanical applications to those theoretical and scientific, occupying himself with water itself and all the phenomena related to it. On September 12, 1508, he began compiling a manuscript (Codex F) that contains, among other things, observations on the movement and measurement of water, a theme made increasingly compelling by his frequent activities as a hydraulic engineer. In fact, by the 1490s the subject appears in page after page of his codices, often with the clear intention of giving it a thorough analysis, in all its aspects, in a "book of water."

Above: Leonardo, *The Embryo in the Uterus,* ca. 1511–13; Royal Library, Windsor.

Left: Leonardo, *Studies of the Flow of Water,* 1509–11; Royal Library, Windsor.

Right: Leonardo, *Landscape of Tre Corni,* 1509–11; Royal Library, Windsor. While surveying the course of the Adda River, Leonardo portrayed the locality near which he intended to build a dike.

In 1509 Leonardo was busy taking geological and hydrographic surveys related to the expansion of the river network of Milan by means of a navigable route that would connect the city to Lake Como and the Alpine passes of Splugen and the Engadine. The solutions he came up with constitute the crowning achievement of his research and activity in the field of hydraulics. First he concentrated on the Naviglio of the Martesana, a length of canal downriver from the Adda River; then he considered using the Lambro River and the lakes of the Brianza area to reach the eastern end of Lake Como; in the end he opted for damming up the course of the Adda between the towns of Trezzo and Paderno at a point where the river presented a natural narrowing, a rocky gorge that prevented the passage of boats. To overcome this, Leonardo proposed the construction of a hundred-foot-high masonry dike with a floodgate opening connected to a basin to lower the level of the water to permit navigation through a tunnel. Since the time of the Sforzas, the project had had great appeal, but its complexity prevented it from being carried out. With the second French occupation of Milan, in 1515, the project was brought up again, and Leonardo, by then far away, is said to have suggested the names of suitable technicians. Not until the end of the sixteenth century was the project completed, and then on such a reduced scale that it failed to achieve the hoped-for economic benefits.

On October 21, 1510, Leonardo met with Giovanni Antonio Amadeo, Cristoforo Solari, and Andrea Fusina—architects and sculptors—to discuss delays in the work on the cathedral, the building on which he had concentrated his efforts as

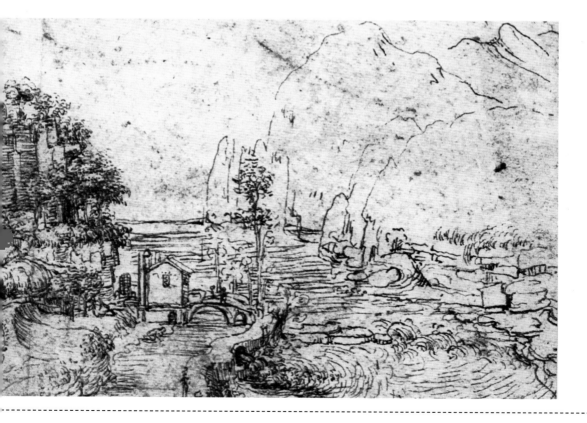

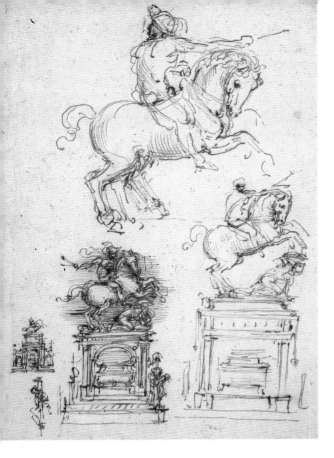

heart," the way rivers rise from the sea. In this period Leonardo's speculations, based on the observation of nature and water itself, of its movements and thus the changes caused by its endless running over the surface of the earth, became increasingly audacious, almost arriving at the overturning of concepts fundamental to Renaissance thought. He made further studies of the geometric principles of the line, point, and surface to find an explanation of the concept of "Nothingness," an idea that arose from meditations on time that date back to his first period in Milan, meaning the concept of the infinite, of being incorporeal, of being timeless. He arrived at an explanation of Nothingness as that which has being, exists in a place, but does not occupy space. This explanation, found in Codex G and datable to around 1510–15, identifies Nothingness as the "existence between the air and a body." He saw all of natural reality surrounded by

an architect during his first stay in Milan. At the same time, he returned to his studies of anatomy, perhaps in part because of the presence of Marcantonio della Torre, professor at Pavia, and wrote that "in the winter of this year, 1510, I hope to complete all this anatomy," meaning the treatise so often undertaken and never completed but referred to in many drawings and notes. His knowledge of the human body, initially directed at external morphology, the proportions of the face, and outer muscles, had become more introspective, coming to look at the circulatory system.

The progress of his studies had an effect on those of hydrodynamics. He realized he had been wrong is comparing the circulation of blood in human bodies to that of water in rivers, an analogy still found in Codex F; having realized the error, he no longer wrote that the veins arose from a "lake near the

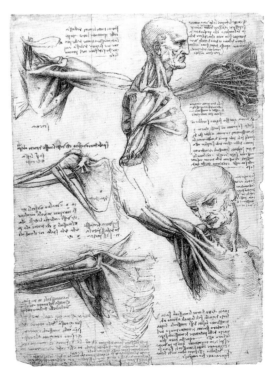

lines, covered by surfaces, wrapped in nothing. In this way he explained one of the most important characteristics of his painting, sfumato: "If the line and also the mathematical point are invisible things . . . then you, O painter, must not make bodies end far from the eye . . . Therefore, painter, do not surround your bodies with drawn lines, above all when representing objects smaller than they are in nature. Not only will these objects not exhibit their lateral boundaries, but the component parts will not be visible from a distance" (Codex G).

Opposite top: Leonardo, *Studies for the Equestrian Monument to Gian Giacomo Trivulzio*, ca. 1508–10; Royal Library, Windsor.

Opposite bottom: Leonardo, *Anatomy of the Right Shoulder*, 1510–11; Royal Library, Windsor.

Right: Raphael, *Julius II*, 1511–12; National Gallery, London.

Below: Leonardo, *Heart and Lungs of an Ox*, 1512–13; Royal Library, Windsor.

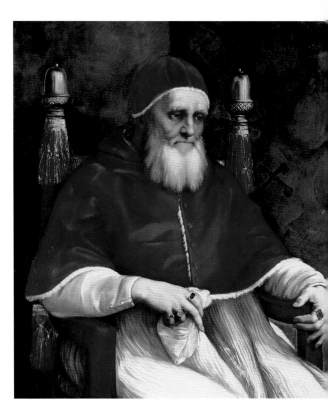

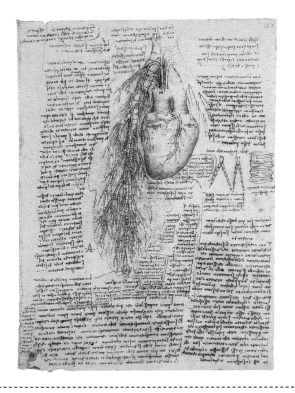

THE LAST ITALIAN PATRONS

In 1511 Leonardo may have been the guest of his favorite student, Francesco Melzi, in his villa at Vaprio d'Adda, for which he may have designed an enlargement. Near the end of the year, on the tenth and the eighteenth of December, he was again in Milan, in time to witness another change in the local political situation and take note of two fires started by some of the Swiss soldiers that had installed Massimiliano, firstborn son of Ludovico Sforza, as duke, after a thirteen-year exile at the imperial court.

The Swiss had been hired the year before by the "warrior pope" Julius II. Determined to increase the church's temporal power, he was carrying on the work begun by his bitter enemy, Alexander VI, but aiming it in the opposite direction, against

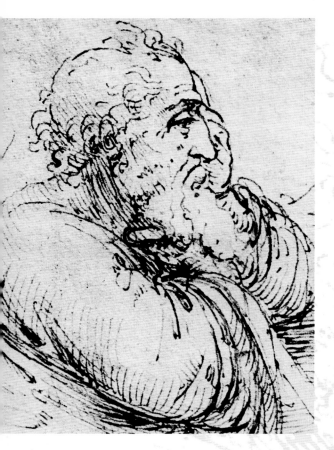

They met on April 11, 1512, near Ravenna and fought a battle in which 10,000 soldiers died, including Gaston de Foix. The Spanish were defeated, but neither side could claim a clear victory. The new French commander, La Palisse, unable to replenish his army's decimated ranks, found himself facing forces from Genoa, Rimini, and Ravenna. The Swiss, Spanish, and Italians rapidly took Parma, Piacenza, Pavia, and also Asti, a hereditary holding of the French crown. Two months after the victory at Ravenna, the French headed home across the Alps, leaving a garrison in Milan. To put order in the confused Italian situation, a meeting was held in Mantua attended by Spain's viceroy of Sicily, Raimondo di Cardona, the bishop of Gurk, sent by the Emperor Maximilian II, and representatives of the pope and Venice. Florence, punished for its French leaning, was given back to the Medici, while Milan, a protectorate of the Swiss canons, was returned to Duke Massimiliano Sforza.

Early in 1513 Leonardo was still in Lombardy; on January 9, at Vaprio, he drew a room of the "Vaveri" tower and during the same period visited Trezzo d'Adda, where he drew a diagram of the castle. The presumed *Self-Portrait* in the Biblioteca Reale of Turin, from around 1512, shows the face of an elderly man with an absorbed expression, beard, and long hair. Leonardo was then sixty, and once again a new route opened before him. The duchy of Milan was heading toward an inexorable decadency: the French, imperial, and Spanish troops that alternately conquered it gradually stripped it of its past splendor. On September 24, 1513, Leonardo left Milan for Rome with his dearest students: Francesco Melzi, Salai, a certain Lorenzo, and "Fanfoja," dubiously identified with the sculptor Agostino Busti, known as Bambaja.

the French, the former allies of the Borgias. Alarmed by the French presence on the peninsula, Julius II led the attack on Ferrara, an ally of France, and took the fortress of Mirandola. The French, under Gian Giacomo Trivulzio, had won back Bologna, destroying every trace of its occupation by the pontifical forces, most particularly Michelangelo's bronze statue of Julius II, which was melted down to make cannons (the head was saved). In October 1511, Julius announced the formation of the Holy League with Ferdinand II of Spain, the republic of Venice, and England's King Henry VIII. The French army, commanded by Gaston de Foix, a young nephew and lieutenant of Louis XII, moved southward to meet the papal and Spanish forces led by Raimondo di Cardona, heading in turn northward.

There was a new pope in Rome. Julius II had

died while preparing to return to battle against Ferrara and had been replaced by a Florentine, Giovanni de' Medici, son of Lorenzo the Magnificent. On the announcement of the death of Julius II, Cardinal de' Medici immediately left Florence, where Medici rule had just been reinstalled, to take part in the conclave, which elected him on March 11, 1513, with the name Leo X. During the pontificate of Julius II, the Eternal City had been restored to its past magnificence. The grandiose, centuries-old programs of popes and the vestiges of the classical world attracted artists and intellectuals; the city became the most important construction site in Europe and saw the rise of new creations that were the apex of the High Renaissance style. Bramante was made director of the large-scale reshaping of the city, directed at centralizing the city around the Vatican, where construction of the Basilica of St. Peter's was beginning, along with the frescoes in the Sistine Chapel by Michelangelo and the *stanze* by Raphael. Carrying on the programs of his predecessor and making them his own, Leo X was to give his name to a period of humanistic splendor. He too had to face a tumultuous political situation, made even more difficult by the Protestant Reformation begun by Luther in Germany in 1517. Seeing to the inter-

ests of his own family, Leo X drove Francesco Maria della Rovere from the duchy of Urbino so he could give it to his nephew Lorenzo, but Lorenzo's early death in 1519 ruined his plans to create a larger state for the Medici.

Leonardo's patron in Rome was not a sovereign but instead a far more influential person: Giuliano de' Medici, duke of Nemours, brother of the pope, a man of letters and a poet, friend of Machiavelli and Pietro Bembo. Giuliano, who had ceded the rule of Florence to his nephew Lorenzo

Opposite: Leonardo, *Self-Portrait*, ca. 1510; Royal Library, Windsor.

Below: Francesco Melzi, *Flora*, ca. 1520; Hermitage, St. Petersburg.

in order to move to Rome and be with Leo X, called Leonardo to his court and had him set up a studio in the Villa del Belvedere, where he worked primarily on scientific studies without overlooking practical applications. Around 1515, for example, he designed a mechanism for rolling copper. For Giuliano, Leonardo conceived a plan to drain the malarial Pontine Marshes, natural extension of the hydraulic studies that had kept him so busy in Florence and Milan, and he performed a survey of the ancient port of Civitavecchia as part of the urbanistic and defensive plans for the city promoted by Leo X.

As had happened during his previous stay in Rome, Leonardo was drawn to the fascination of ancient art, all the more so since ongoing excavations were bringing new works to light that were then assembled in the first open-air statuary museum, set up by Julius II in the courtyard between the Vatican Palace and the villa of the

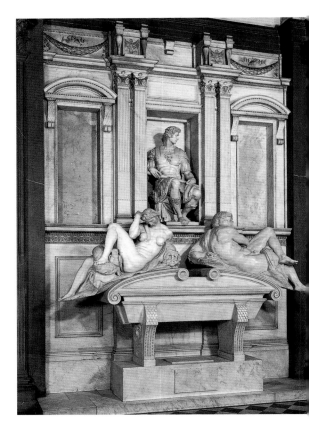

Belvedere. In the preface to Part Three of his *Lives*, Vasari lists the ancient works dug out of the ground that were determinant in the birth of the new "modern manner," including the "Laocoön, the Hercules, the great torso of Belvedere, as well as the Venus, the Cleopatra, the Apollo," all masterpieces displayed at the Belvedere, and some of them already there when Leonardo arrived in Rome. In 1512, the Cleopatra-Ariadne had been acquired, installed as a fountain above an ancient sarcophagus in a corner of the courtyard, as appears in a tiny sketch on a page of the Codex Atlanticus, dated to around 1515. According to Vasari, the style of the previous generation of artists had been "crude and harsh and offensive to the eye." Leonardo, he claimed, had overcome this and had "originated the third style or period, which we like

to call the modern age; for in addition to the force and robustness of his draftsmanship and his subtle and exact reproductions of every detail in nature, he showed in his works an understanding of rule, a better knowledge of order, correct proportion, perfect design, and an inspired grace. An artist of great vision and skill and abundant resources, Leonardo may be said to have painted figures that moved and breathed." The ancients were still the standard against which Renaissance artists were judged, and Leonardo held up to the comparison because he imbued all his images with the naturalness of ancient examples.

Although by then an old man involved in other activities, Leonardo did not stop painting and drawing. He remained faithful to his habit of reworking his creations, continued to accumulate new experiences and observations, and also took on commissions for works that he might never complete.

Around 1514 he seems to have been still working on the *Leda,* drawing on the classical group of the Nile, discovered in 1512 and added by Leo X to the Belvedere museum, for the positions of the children at her feet. A page of the Codex Atlanticus, datable to 1515–16, bears a pen drawing of an eye touched by a lock of wavy hair, much like in the *Mona Lisa:* past works, like details of works in progress, might reappear at any time. Antonio de' Beatis, visiting the painter's studio in France in 1517, saw the portrait of a "certain Florentine woman made from nature at the instigation of the late Magnificent Giuliano de' Medici." This citation suggests that the painting, presenting a woman dear to Giuliano, was completed in Rome between 1513 and 1515.

The charcoal study known as the *Pointing Lady in a Landscape* dates to about 1515 and may relate to a series of ideas that Leonardo was developing.

Opposite top: Michelangelo, tomb of Giuliano de' Medici, 1520–34; Sacrestia Nuova, San Lorenzo, Florence.

Opposite bottom: Raphael, *Leo X,* 1518–19; Uffizi, Florence. Lorenzo the Magnificent's two sons fulfilled his dreams for them, reaching lofty positions in the church and politics and proving themselves worthy heirs to the Medici tradition, also in the patronage of the arts.

Right: Leonardo, *The Pontine Marshes,* ca. 1515; Royal Library, Windsor.

The woman, located in an idyllic landscape on the banks of a stream, has a questioning smile, not unlike that of the *Mona Lisa*. She has been interpreted as a depiction of the nymph Matelda, encountered by Dante in his *Purgatory*. If such is the case, this would be the only instance in which Dante's *Comedy,* well known to Leonardo as well as to all his contemporaries and illustrated by Botticelli, appears in a work by Leonardo.

According to another interpretation, the woman was meant to be inserted in a far larger composition and might be an introduction to his series of

Deluges, generally dated to a few years later.

Whatever the origin of the drawing, with its highly refined execution, it is an allegory that confirms the tireless power of Leonardo's imagination. The billowing clothes, which reveal and amplify the underlying forms, is related to his recommendation in *Treatise on Painting:* "As much as you can, imitate the Greeks and Latins in the way in which the limbs are revealed when the wind presses the draperies over them." The same type of drapery is found in studies for the unfinished part of *The Virgin and Child with St. Anne* in the Louvre, on which he worked during his final years.

While living in Rome, Leonardo made various trips. On September 25, 1514, he was in Parma, perhaps as a military adviser to Giuliano de' Medici; then he was at Sant'Angelo, in Bologna, and Florence.

In December 1515 he accompanied Giuliano de' Medici and Leo X to Bologna to meet the new king of France, Francis I, whose first act as king had been a triumphant expedition to Italy. Allying himself with Venice, the young king had led his army to the border and, to the dismay of the

Leonardo

Among the great things which are found among us the existence of Nothing is the greatest. This dwells in time, and stretches its limbs into the past and the future, and with these takes to itself all works that are past and those that are to come, both of nature and of the animals, and possesses nothing of the indivisible present. It does not however extend to the essence of any thing.

(Codex Atlanticus)

Holy League members, the king of Spain, the emperor, and the pope, he had headed straight for Milan.

Having failed to halt his descent through the Alpine passes, the Swiss had closed themselves into Castello Sforzesco in a vain attempt to defend Milan. Between September 13 and 14, 1515, at Marignano (today's Melegnano), the French cavalry, led by Gian Giacomo Trivulzio, made a frontal attack on the Swiss and German mercenaries of the league and, with the decisive help of the Venetians commanded by Bartolomeo d'Alviano, won a crushing victory. Francis I had entered Milan, and Massimiliano Sforza had gone into exile.

After this serious defeat, the Swiss Confederation no longer officially participated in battles, nor did it permit troops to be enlisted from its cantons.

In an encounter at Bologna, the French king and the pope settled the conditions for the peace and signed an agreement on the basis of which the king of France acquired the right to name bishops and to establish ecclesiastic offices. The accord that decided, even if only temporarily, the fate of Italy, was drawn up at Noyon between Francis I and Charles V, king of Spain. According to this agreement, the kingdom of Naples remained in Spanish hands and the duchy of Milan was given to the French. As a member of the papal retinue at Bologna, Leonardo had his first meeting with his next and last patron.

Opposite: Leonardo, *Pointing Lady in a Landscape,* ca. 1515; Royal Library, Windsor.

Above: Leonardo, *Deluge,* ca. 1517–18; Royal Library, Windsor.

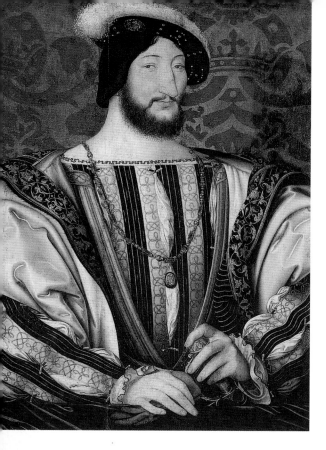

The Move to France

Leonardo was still in Rome in August 1516, where he took measurements of the Basilica of St. Paul. Giuliano de' Medici had died in March following a long disease, which may have convinced Leonardo to accept the invitation from Francis I to go to France in the winter of 1516–17; Salai and Melzi went with him. In May 1517 he was in the castle of Cloux, near Amboise, but he made frequent visits to other castles on the Loire, following the itinerant habits of the French court.

In the employ of a young and energetic monarch, an educated man and art lover bursting with enthusiasm, Leonardo, more than sixty, felt called to new undertakings. His primary role in all sectors of activity, which until then he had so spectacularly performed, was now repeated in his role of *premier peinctre et ingénieru et architecte du Roy,* conferred on him by Francis I.

As hydraulic engineer he designed an irrigation canal involving the waters of the Saône between Tours and Blois, similar to the arrangement planned for the Isonzo River early in the century. As architect he furnished drawings for a palace to be built at Romorantin for the queen mother, Louise of Savoy. The palace, based on a grandiose design, was to be a monumental residence with all the comforts useful to the ruler, with halls, courtyards, and playing fields. It was to stand on the banks of a river—on which spectacular naval battles would be enacted—that would have provided hygiene and also the motive power for the castle and its annexed buildings. The project extended to the surrounding town, with areas for artisans and merchants, and included reclamation projects for repopulating the region, the valley of the Sologne around Romorantin. As part of his plans for draining the marshes, and to make possible the rapid movement of people, Leonardo introduced the concept of prefabricated houses for the first time in modern history: "Let the houses be transported and arranged in order, and this can be done with ease because these houses are first made in parts upon the open places and are then fitted together with their timbers on the spot where they are to remain."

An epidemic, a result of the marshy nature of the area, forced the end of work on the construction of the castle. The project was moved to nearby Chambord and continued on the basis of Leonardo's designs. In both his urban projects and those for buildings, Leonardo always concentrated

Above: Jean Clouet (?), *Francis I,* ca. 1530; Louvre, Paris. Admirer of the Italian Renaissance, Francis I supported its diffusion to France.

Francis I

(Cognac, 1494–Château Rambouillet, 1547)

Son of Charles d'Orléans, count of Angoulême, and Louise of Savoy, Francis married Claude, daughter of Louis XII, in 1514, and succeeded him on the throne of France in 1515. He continued his predecessor's Italian campaigns, winning back the duchy of Milan with his victory over Massimiliano Sforza at Marignano. In the struggle for the Holy Roman emperor's crown, he lost to his rival Charles V, whose dominions surrounded France and forced Francis into an anti-Hapsburg policy. His attempts to form an alliance with England's Henry VIII proved futile, and he was defeated and taken prisoner by imperial troops at Pavia in 1525. Held captive in Madrid, he gained his freedom by signing a treaty obliging him to cede the duchy of Milan and Burgundy to Charles V; once free, however, he refused to abide by it since it had been signed under duress. With the Treaty of Cambrai in 1529, France and Spain agreed to their respective zones of influence; France agreed to abide by the treaty signed at Madrid but was allowed to keep Burgundy. Hostilities did not cease, however. To weaken his adversary, Francis allied with German princes and the Turkish sultan Sulayman I. Francis again attacked the emperor in 1536, but despite the conquest of Nice and Savoy, the invasion of France led Francis to sign the Treaty of Crépy (1544), reconfirming the earlier situation. In domestic affairs, Francis I expanded the absolutism of the monarchy and sought to weaken the nobility, limiting it to court functions. A great admirer of the Italian Renaissance, Francis favored the adoption of the new style in France and invited many artists to his court.

Below: Taddeo Zuccari, *Charles V and Francis I*, 1559–66; Palazzo Farnese, Caprarola.

artist's desire to please his patrons. Preparing fabulous spectacles, theatrical presentations, and parades reveals another side of his character, not that of the scientist and researcher artist obedient to universal rules of nature, but that of the dreamer and creator of images. For the French court, Leonardo made use of his talent for creating astonishing mechanical contrivances. At Argentan in 1517, he showed his skill in the "minor" art of creating automatons, producing a moving lion that stopped and opened to display to the king an interior full of lilies and other flowers. The "marzocco," the lion of Florence bearing the lily of France in the place of its heart, symbolized the munificence of the king, alongside whom Leonardo spent the last years of his life. In

on problems of utility and suitability to purpose, without, however, losing sight of beauty, which he saw as an integral aspect of suitability and which was based on the harmony of the proportions.

Despite his enormous involvement in art and architecture and the praise heaped on him by his contemporaries, patrons, and workers, including comments on his talent as an architect, no building designed by Leonardo was ever built.

His responsibilities included the organizing of court entertainments. The enthusiasm he demonstrated in the performance of such chores should not be mistaken for merely a professional

1515 a mechanical lion designed by Leonardo was sent to Lyons for the cortege of the coronation of Francis I, and a similar object was also sent to Florence, which took on a precise political significance in terms of the friendship between the city and France. The ties between the Medici family and the French royal family were made tighter through the bonds of matrimony, celebrated with appropriate entertainments. The marriage of the king's cousin Madeleine de la Tour d'Auvergne to Lorenzo de' Medici involved Leonardo as stage designer in May 1518. In June, in honor of Francis I, he prepared apparatuses similar to those used in the *Festa del Paradiso* of 1490. The days of the Florentine jousts and the courtly ceremonies of Ludovico Sforza seemed brought back to life. In

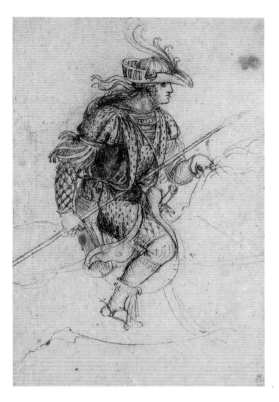

Opposite: Leonardo, *Study for a Costume*, 1517–18; Royal Library, Windsor.

Left: Leonardo, *Study for a Dragon*, 1517–18; Royal Library, Windsor.

Above: Leonardo, *Study for a Costume*, 1517–18; Royal Library, Windsor.

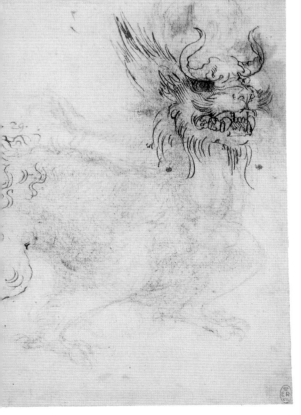

France, tournaments were the order of the day and involved the great heroes of chivalric epics; Francis I liked to take the part of a character from the Round Table, most of all King Arthur. Leonardo's drawings with studies of costumes may have been related to one of those occasions. The bronze sculpture of a horseman on a rearing horse recently attributed to Leonardo may well present Francis I as King Arthur.

Other drawings dated to around 1517 to 1518 reveal that nature, in its most explosive and catastrophic manifestations, was still the subject of passionate study by Leonardo. The series of so-

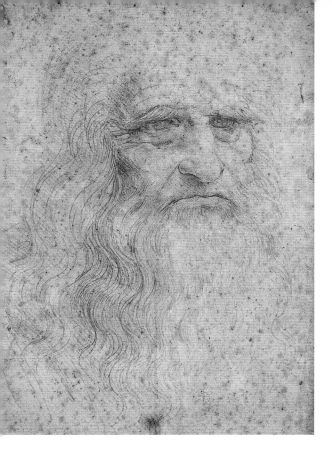

Beatis, we know that on October 10, 1517, the cardinal visited Leonardo in his studio at Cloux and saw three paintings: the portrait of a Florentine woman, a young St. John the Baptist, and a "Virgin and Child, which are placed in the lap of St. Anne." The descriptions match the three panels today in the Louvre: the *Mona Lisa*, *St. John the Baptist*, and *The Virgin and Child with St. Anne*, begun in Italy and brought to France. The cardinal and his secretary were also able to see anatomical studies, and they discussed drawings of hydraulics and machines and other subjects that Beatis noticed in the studio.

Beatis noted that the master was old and had been struck by a "certain paralysis of his right hand," so was no longer able to paint "with the sweetness of style that he used to have." Yet he continued to make drawings and to teach others, most of all Melzi ("a Milanese disciple"), who assisted

called *Deluges* shows the primordial forces of nature in their extreme manifestations. In these apocalyptic images, water forms tumultuous waves, rising to crash over rocks, bend trees, and overturn all of creation. The Flood—the end of the world—takes place in obedience to an intimate necessity, the law of nature that Leonardo saw in chaos and that was visible in the lines of force in water and wind, becoming a means of artistic expression. Before all other things, Leonardo was always a great painter, and even though old age prevented him from painting with the energy of his earlier years, he did not forget the highest expressions of his creativity, the crowning works of all his research. From the *Itinerary of Cardinal Louis of Aragon*, compiled by his secretary Antonio de'

him and probably completed his paintings.

The final record of the presence of Leonardo at Amboise dates to June 24, 1518. On May 2, 1519, he died in the castle at Cloux, according to legend in the arms of Francis I, and was buried in the church of St. Florentin at Amboise, as he had requested in his will, drawn up on April 23. Francesco Melzi, the sole executor and principal beneficiary, inherited, in remuneration for services

at Santa Maria Novella to his half-brothers. He made arrangements for his maidservant Maturina and for his funeral, requesting the participation of sixty poor men each carrying a taper, to be paid at the discretion of Melzi.

In the disorder of the Huguenot Wars fifty years later, the remains of Leonardo were lost.

The paintings in the studio at Cloux became the property of Salai, who brought them to Lombardy,

and kindnesses rendered, all the manuscripts, drawings, and tools related to the profession of painter; all his money, including the fees still owed him by the royal treasurer; and his clothes. To his servant Battista he left half of a property in Milan, the other half going to Salai, along with the house that Salai had already built on the property. He left a property in Fiesole and the money on deposit

where they contributed to the diffusion of the Leonardesque style. Following Salai's death in 1524, they entered the art market. Melzi cataloged the manuscripts he had inherited and took care of them—treating them like reliquaries—in his villa at Vaprio d'Adda. On his death in 1570, they passed to his children, who, heedless of their inestimable value, got rid of them, beginning their dispersion.

The Codices
Origins, histories, and current locations

Very few artists have left written testimony comparable, in terms of abundance and importance, to that of Leonardo. No more than four paintings are universally attributed to him, but thousands of pages are incontestably from his hand, all of them covered with his famous right-to-left mirror handwriting.

Altogether, more than five thousand pages remain on which Leonardo examined an astonishing variety of subjects in the form of notes, calculations, annotations of citations from others, personal observations, extemporaneous comments, sketches, and drawings. Some are of a purely artistic character, some are related to scientific concepts. While this impressive paper patrimony does not represent the totality of what Leonardo produced over the course of his titanic career, it does provide a measure of the complexity and wealth of his world vision and his extraordinary curiosity about all things.

The Vincian texts do not contain organic treatises complete unto themselves on specific subjects and in most cases consist instead of miscellanies covering a variety of subjects. They are almost always presented in the form of quick notes, often just a few lines, only rarely longer than a page. The same note can be repeated dozens of times in different manuscripts with only slight variations. In many cases Leonardo returned to pages he had written years before and filled in empty spaces with new writing. Despite his intentions to give a definitive arrangement to his research, compiling a separate "book" for each discipline—at various times he decided to make such works on subjects like anatomy, geometry, or the movement of water—only one book expresses in an exhaustive manner Leonardo's thoughts, or poetics, on a single subject, but it is the subject that composed the fulcrum of all his research: painting. This is the *Treatise on Painting* compiled by his student Francesco Melzi using a selection of the texts that Leonardo transcribed in what is known as the Codex Urbinas (now Vatican 12790). Foglio 231 contains a list of the eighteen original manuscripts from which Melzi drew to compose the *Treatise,* each marked with a symbol.

Leonardo saved his notes and studies and put

Top: The "tired hand," meaning the left, with which Leonardo wrote, drew, and painted; Codex Atlanticus.

Above: Capital letters from Leonardo's alphabet, taken from the Madrid Codex I.

great store by them since they were his principal tool of work. It often happened that he would return to the same sheet of paper after an interval of several years. He bound them or glued the sheets to the pages of volumes or albums.

Several decades after his death, this body of graphic works had been widely dispersed, but those who understood its exceptional value began trying to track it down, with the result that over the centuries a series of codices of various sizes came into being, preserved in various places. In the sixteenth and later centuries, some of the notebooks were dismembered or cut up, the pages removed or rearranged; in some cases pages were removed from their original notebooks to be assembled with others on the basis of arbitrary thematic groupings.

The discovery in 1965 of two Leonardo manuscripts in the Biblioteca Nacional of Madrid, today known as Madrid I and Madrid II, was of particular importance. The future may well hold other similar discoveries, but the numerical growth of the manuscripts has not been as important as the philological approach to the Vincian notebooks, which has made possible the increasingly accurate clarification of the evolution of Leonardo the artist, the man of science, and the inventor, thus casting light on areas that had long been in shadow.

The story behind the dispersion of the Vincian papers is complicated but also essential to an understanding of the current division and location of the codices.

When Francesco Melzi returned to Lombardy in 1519, he brought with him all the manuscripts that Leonardo had left him. He cataloged them, preserved them in his villa at Vaprio d'Adda with extreme care, and resisted the enticements of the Milanese agent of the duke of Ferrara, who was eager to buy those treasures. On his death in 1570, his heirs, knowing nothing of the importance of the Vincian pages, stored them in a loft. Because of the scant consideration given the notebooks, Lelio Gavardi, an assistant in the Melzi household, did not believe he was committing a crime when he took thirteen of the manuscripts and tried to sell them to the grand duke of Florence, who died before concluding the affair. Overcome with remorse, Gavardi turned to a friend, the Barnabite Giovanni Ambrogio Mazenta (who later told the story in a reasonably believable document entitled *Memories of the Events of Leonardo da Vinci in Milan and His Books*), and asked him to return the manuscripts to Orazio Melzi. When Melzi stated that he had no interest in having them, the thirteen manuscripts ended up being divided between Mazenta's two brothers, six to Guido and seven to Alessandro.

At this point a figure of central importance to the history of the manuscripts appears: Pompeo Leoni, official sculptor to Philip II of Spain and a major collector. He was active mostly in Spain, but in 1582 he returned to Milan for ten years and thus was on hand during the period in which the heirs of Melzi were dismembering the Vincian manuscripts and drawings piece by piece. Well aware of their value and determined to own them, Leoni obtained all the volumes owned by Alessandro and

after fifteen years had come into half of those of Guido Mazenta. In the meantime, the other half had been given to Cardinal Federico Borromeo (today's MS C, Paris, Institut de France), to Duke Charles Emmanuel of Savoy, and to the painter Giovanni Ambrogio Figino.

Leoni eventually succeeded in assembling about fifty manuscripts, for the most part from the Melzi villa, either directly or by way of the Mazenta family, taking his search in every possible direction in the hope of assembling and eventually rebinding every fragment of paper related to Leonardo. Like Melzi, Leoni cataloged the manuscripts, arranging them according to format, from the largest to the smallest, and affixing a progressive number and an alphabetic mark to the beginning or end of each volume. The number and alphabetic mark were followed by the number of pages in each volume. Only nineteen of those volumes are known today, and the highest number is 46. Leoni also came into possession of a large number of loose pages bearing writing or drawings, of various sizes, which he classified and assembled, gluing them to the large pages of two albums. One of these, entitled *Drawings of Leonardo da Vinci, Restored by P. Leoni,* contained about six hundred drawings; it later formed a large part of the wonderful collection in the Royal Library at Windsor. The other volume, entitled *Drawings of Machines and Secret Arts and Other Things by Leonardo da Vinci, Collected by P. Leoni,* is today called the Codex Atlanticus because of the format (that of an atlas) of the 400 pages to which the Vincian works were attached.

The Leonardo manuscripts collected by Leoni were transferred to Spain, where the sculptor lived until his death, but despite his avowed intention of giving all the works to the king, he did not do so.

Early in the eighteenth century the Madrid I and Madrid II manuscripts were in the library of Philip V, where they remained until 1830. Lost during the transfer to what is today the Biblioteca Nacional, they were found after careful research in 1965.

Other manuscripts brought to Spain were later taken to England. Some were returned to Milan.

On the death of Pompeo Leoni in Madrid in 1608, his heirs offered Cosimo II of Tuscany the Codex Atlanticus and "fifteen other books of observations and labors . . . particularly on anatomy," but the transaction was never concluded. The property passed to Pompeo Leoni's son-in-law, Polidoro Calchi, and around 1635 he sold the Codex Atlanticus for 300 scudos to Count Galeazzo Arconati, who during the 1730s came into possession of other Leonardo notebooks, identified as the fifteen offered to Cosimo II.

In 1637 Galeazzo Arconati gave the Biblioteca Ambrosiana in Milan a group of Vincian manuscripts—the bulk of his collection. These are recognizable from the act of donation as the Codex Atlanticus, the Codex Trivulzianus, and the manuscripts today known as A, B, E, F, G, H, I, L, and M. The founder of the Ambrosiana, Cardinal Federico Borromeo, was a great admirer of Leonardo's work and, as has been seen, already owned Manuscript C, which deals with "shadows and lights very philosophically, useful for the painter and for the study of perspective and optics." Arconati's gift, commemorated in a marble plaque still in the Ambrosiana, was made more meaningful by the fact that to "not deprive our homeland of such a treasure," he had refused to sell the "big book" (the Codex Atlanticus) to the king of England, despite the offer of quite a large sum. In reality, the collector who was willing to do anything to come by the work of Leonardo was Thomas Howard, count of Arundel, one of the leading collectors of the period. Pretending to act as an intermediary for the king, he had struggled with the governor of Milan "to obtain the greatly desired book."

Arconati reserved the right to keep the volumes in his home for the time necessary to make copies of them (the last was made in 1644), and he later exchanged the Codex Trivulzianus for Manuscript D. Manuscript K and the Codex Forster may have remained in his possession. The Codex Trivulzianus, originally composed of ninety-two pages, had been reduced at the time of Pompeo Leoni to fifty-five; it was further cut down to fifty-four during the period of Arconati to reach today's fifty-one. In 1770 it was sold by Gaetano Caccia to Prince Trivulzio, to then pass 150 years later to Milan's city library with the rest of the Trivulzio collection. Codex K was donated to the Ambrosiana by Count Orazio Archinti in 1674.

The Biblioteca Ambrosiana thus came to possess thirteen manuscripts by Leonardo. These were transferred to Paris by Napoleon in 1796; only the Codex Atlanticus was returned to Italy in 1815. Manuscripts A and B were dismembered in the nineteenth century to create the Codex Ashburnham and the Codex "On the Flight of Birds."

At this point we must return to Pompeo Leoni and his Spanish possessions, most of which were sold to the prince of Wales, later King Charles I, who had visited Spain in 1623. According to two inventories, from 1609 and 1613, those items included a 174-page volume containing studies by Leonardo, one with 234 pages that had been "restored" by Leoni, and two volumes, 268 and 206 pages respectively, of small and large drawings.

The 234-page volume, which became the possession of Count Arundel in 1630, has been identified as the collection today at Windsor.

Arundel also owned the compilation of drawings by Leonardo now known as the Codex Arundel, which is not mentioned in any of Leoni's inventories and which reached the count in a mysterious way between 1635 and 1637; his collection also included loose drawings, among them an important group of caricatures. In 1666 Henry Howard gave it to the Royal Society, and it was then transferred to the British Museum (now the British Library) in 1831–32. The grandiose Arundel collection was cast to the four corners of the world after his death in 1646, and it is possible that the Windsor volume, first recorded among the royal property in 1690, and other drawings were acquired for the royal collection in Germany or Holland around 1675.

The history of the Forster manuscripts is obscure. They were purchased by Lord Lytton in Vienna, passed from him to John Forster, and were donated to the Victoria and Albert Museum in 1876.

The Codex Leicester, also known as the Codex Hammer, belonged to the Milanese sculptor Guglielmo della Porta in the sixteenth century and was bought in Rome in the eighteenth century by Thomas Coke, count of Leicester. In 1980 it was bought at auction by Armand Hammer and then in 1994 by Bill Gates.

Pompeo Leoni's binding of pages by Leonardo; Royal Library, Windsor.

Codex Arundel, British Museum, London. Created from the assembly of 283 pages, arranged in seventy-one groups of different origin, subject, and period, datable to between 1478 and 1518, glued to support pages of 11 x 7⅛ in., with morocco leather binding. There are studies on physics and mechanics, optics, Euclidean geometry, weights, and architecture, the latter including the works related to the royal residence at Romorantin.

Ashburnham Codices I and II, Institut de France, Paris. Also known as BN 2037 (ex Codex B) and BN 2038 (ex Codex A), these date respectively to the end of 1480–90 and 1492. Both manuscripts are paper, 9½ x 7½ in., bound in cardboard. They were originally part of the last pages of Codices A and B, secretly torn out in the nineteenth century by Count Guglielmo Libri and sold in England as autonomous codices to Lord Ashburnham, who, learning of the crime, returned them to Paris. They are composed primarily of pictorial studies (Ash. 2038) and various studies (Ash. 2037).

Codex Atlanticus, Biblioteca Ambrosiana, Milan. This covers a vast period of Leonardo's activity, from 1478 to circa 1518. It consists of more than 1,200 sheets of various size glued by Pompeo Leoni in the sixteenth century to 400 large pages, then removed, restored, and reunited in the second half of the twentieth century in twelve volumes bound in leather, composed of 1,119 support pages, 25⅝ x 17⅜ in. It acquired notoriety only in 1872. It contains 1,750 drawings of various kinds, some artistic in character but others of artillery, fortifications, warships, steamships, flying machines, and machines for the textile and metallurgy industries; there are also notes on physics and chemistry, and research on hydraulics, surveying, cartography, astronomy, and mechanics.

Codices Forster I, II, and III (including I¹, I², II¹, and II²), Victoria and Albert Museum, London. Previously known as SKM I, II, and III. These are three paper manuscripts bound in parchment that measure respectively 5¾ x 4 in., and 7⅜ x 2¾ in., and 3½ x 2⅜ in. Forster I is usually dated to late in the decade 1480–90 and to 1505; II to the middle of the decade 1490–1500; and III to circa 1493–94. They contain studies of geometry, physics, architecture, hydraulic machines, and various notes, including those on *The Last Supper*.

Institute of France Codices, Institut de France, Paris. These are twelve paper manuscripts, some bound in parchment, some in leather, others in cardboard. They are of different measurements, the smallest being Codex M (4 x 2¾ in.), the largest Codex C (12⅜ x 8¾ in.). By convention, they are

Original binding of the Codex Atlanticus;
Biblioteca Ambrosiana, Milan.

named for letters of the alphabet, from A to M, with a total of 964 sheets. They deal with a variety of subjects—military arts, optics, geometry, the flight of birds, hydraulics—and were made at a variety of times: A in and around 1492; B, end of the decade 1480–90; C, 1490–91; D, probably 1508; E, 1513–14; F, 1508; G, 1510–15; H (including H^1, H^2, and H^3), 1493–94; I (including I^1 and I^2), end of the decade 1490–1500; K (including K^1 and K^2, sheets 1–80, and K^3, sheets 81–128), circa 1503–05, circa 1506–08; L, circa 1497–1502; M, end of the decade 1490–1500.

Codex Leicester (ex Codex Hammer). Acquired in 1994 by Bill Gates, this is a paper manuscript, bound in leather, composed of thirty-six sheets, $11^3/_8$ x $8^5/_8$ in., datable to 1507–10, dedicated primarily to hydraulics and the motion of water, and to a lesser degree to astronomy.

Madrid I, Biblioteca Nacional, Madrid, also known as MS n. 8937. Composed of 192 sheets, $8^1/_4$ x 6 in., bound in red morocco leather. Based on the volume marked A 190 by Pompeo Leoni, who united in it two volumes that Leonardo had intended to be the two parts of the same work. The missing pages were lost through the operations performed

by Leoni. It is datable to 1490–1500 and contains technical drawings and notes on mechanics, transcribed and elaborated on pages contained in the Codex Atlanticus and in pages of notebooks dating to 1493–97.

Madrid II, Biblioteca Nacional, Madrid, also known as MS n. 8936. Composed of 157 sheets, $8^1/_4$ x $5^7/_8$ in., bound in red morocco leather. It consists of a sort of jumble, a fascicle of pages that Leonardo used as notebooks in the years between 1503 and circa 1505 (pages 1–140, joined by Leoni in the volume marked C 140), dealing with geometric studies but also notes on flight similar to those in the codex in Turin. The last fascicle (pages 141–157), written between 1491 and 1493, is entirely dedicated to the casting of the horse of the Sforza monument.

Codex Trivulzianus, Biblioteca Trivulziana, Castello Sforzesco, Milan. This is composed of a fifty-five-page fascicle, $8^1/_8$ x $5^1/_2$ in., datable for the most part to the middle of the decade 1480–90 and the early 1490s. It contains studies of military and religious architecture and many pages of Leonardo's self-taught lessons designed to improve his literary training.

Codex Urbinas and Libro A, Musei Vaticani, Rome. These were compiled by Melzi (but transcribed by a scribe) on the basis of various manuscripts, including Libro A of circa 1508.

Codex "On the Flight of Birds," Biblioteca Reale, Turin. This is composed of seventeen pages of the eighteen original, $8^1/_4$ x $5^7/_8$ in., datable to 1505. At the middle of the nineteenth century, Guglielmo Libri, French professor of mathematics, stole numerous pages from Manuscript B, including the entire codex on the flight of birds. In 1867 Count Giacomo Manzoni acquired thirteen pages from Libri; Libri had sold the other five on the London market. In 1920 the codex was reintegrated with the missing pages in the royal library of the house of Savoy in Turin. Twenty-eight of the thirty-six faces of the pages are dedicated to drawings and tiny notes concerning the various phases of the flight of birds, with a strict mechanical approach that involves the study of the function of the wing, air resistance, and winds and currents.

Windsor Folios, Royal Library, Windsor Castle. This collection is composed primarily of dismembered manuscripts but also has loose pages, adding up to about 600 drawings, not bound and of varying formats. There are studies of anatomy and geography, studies of horses, drawings, caricatures, as well as maps from various periods between 1478 and circa 1518.

Chronology
Principal events during the period of Leonardo

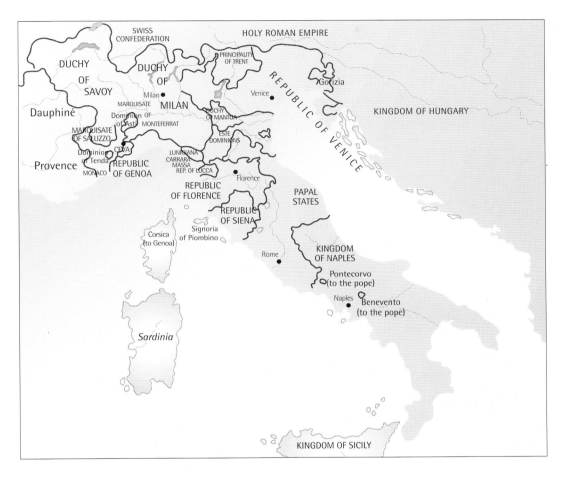

1453 The Turks of Muhammad II conquer Constantinople, ending the Byzantine Empire.
1454 The Peace of Lodi establishes peace among the Italian states.
1454–56 Gutenberg prints the first book using movable type.
1466 Death of Francesco Sforza, duke of Milan; he is succeeded by his son Galeazzo Maria.
1469 Birth of Vasco da Gama.
Birth of Niccolò Machiavelli, pioneer of modern political thought.
Lorenzo de' Medici rules Florence.
1471 Birth of Albrecht Dürer, painter and engraver.
Francesco della Rovere is elected pope as Sixtus IV.
1472 First printed edition of *Divine Comedy*.
1473 Birth of Nicholas Copernicus, asserter of the heliocentric theory.

1474 Marriage of Isabella of Castile and Ferdinand of Aragon, laying the basis for the union of the two kingdoms.
1475 Birth of Michelangelo Buonarroti, sculptor, painter, architect, and poet.
Birth of Cesare Borgia, son of Cardinal Rodrigo Borgia.
Birth of Francisco Pizarro, conqueror of the Inca Empire.
1476 Assassination of Galeazzo Maria Sforza; his son Gian Galeazzo inherits the title but his brother Ludovico takes possession of the duchy.
1477 Birth of Titian.
Maximilian I marries Mary of Burgundy.
1478 Birth of Thomas More, statesman and philosopher.
Pazzi conspiracy and death of Giuliano de' Medici; Florence's reaction leads to a papal interdiction and war.

1479 Death of the painter Antonello da Messina.
1480 Sixtus IV withdraws the interdict and signs a peace treaty with Florence.
Ivan III frees Muscovy from the Tatars and becomes tsar of all the Russias.
1483 Birth of Martin Luther, religious reformer.
Birth of Raphael, painter and architect.
Death of Louis XI of France; he is succeeded by Charles VIII.
In Spain the Dominican Torquemada is named grand inquisitor, beginning religious fanaticism with thousands condemned to death.
1484 Giambattista Cybo is elected pope as Innocent VIII.
1485 Henry VII becomes king of England.
Matthias Corvinus, king of Hungary, conquers Vienna.
1486 Maximilian I is elected king of Germany.
1487 The Spanish take Malaga from the Muslims.
1488 Death of Andrea Verrocchio, sculptor, painter, and teacher of Leonardo.
Bartolomeu Dias rounds the Cape of Good Hope.
1489 Venice occupies Cyprus.
1492 Christopher Columbus reaches San Salvador, an island in the Bahamas.
Death of Lorenzo de' Medici.
Death of Piero della Francesca.
The Spaniard Rodrigo Borgia becomes pope as Alexander VI.
Ferdinand and Isabella conquer Granada, completing the *reconquista* of Spanish territory.
They expel all Jews and Muslims from Spain.
1493 Maximilian I becomes emperor of the Holy Roman Empire.
1494 The French enter Italy in support of Anjevin claims to Naples.
Piero de' Medici is driven from Florence, and Savonarola takes power.
1495 Charles VIII takes Naples.
Ludovico Sforza is made duke of Milan.
1497 John Cabot, Venetian in the service of England, reaches the North American continent.
1498 Savonarola is declared a heretic and executed in Florence.
Death of Charles VIII; he is succeeded by Louis XII, king of France until 1515.
Vasco da Gama discovers the route to the Indies.
1499 Louis XII allies with Venice and Florence against Milan.
Switzerland wins freedom from the Holy Roman Empire.

1500 Ludovico Sforza is defeated and taken prisoner by the French.
Birth of Charles V, Holy Roman emperor from 1519 to 1556.
1501 Spanish introduce slavery to the New World.
Cesare Borgia becomes duke of Romagna.
1503 The death of Pope Alexander VI begins the decline of Cesare Borgia.
After the brief pontificate of Pius III, Giuliano della Rovere becomes pope as Julius II.
1504 The kingdom of Naples and Sicily becomes Spanish (and will remain so until 1713).
Michelangelo sculpts *David*.
Raphael paints *The Marriage of the Virgin*.
1506 Creation of the Swiss Guards.
Bramante starts construction of St. Peter's in Rome.
Pope Julius II begins a series of wars in Italy.
Machiavelli forms the Florentine militia.
1508 Maximilian I, Louis XII, Ferdinand II of Spain, and (in 1509) Julius II form the League of Cambrai against Venice.
Michelangelo begins painting the ceiling of the Sistine Chapel.
Raphael is commissioned to paint the Vatican Stanze.
1509 Henry VIII becomes king of England.
Birth of John Calvin, theologian and reformer.
Erasmus writes *The Praise of Folly*.
1510 Death of Sandro Botticelli.
1511 Julius II, Venice, and Ferdinand II of Spain form the Holy League against France.
1512 Giuliano de' Medici, duke of Nemours, rules Florence.
Defeat of the French at Pavia.
Massimiliano Sforza rules Milan.
1513 Giovanni de' Medici becomes pope as Leo X.
Lorenzo de' Medici rules Florence.
1515 Francis I succeeds Louis XII on the throne of France and continues the campaign in Italy; defeats Massimiliano Sforza and takes Milan.
1516 Ludovico Ariosto writes *Orlando Furioso*.
1517 Martin Luther posts his ninety-five theses in Wittenberg, beginning the Protestant Reformation.
The Portuguese reach Canton by sea.
1518 Publication of *Utopia* by Thomas More.
1519 Charles V, already king of Spain as Charles I, becomes Holy Roman emperor.
Luther is condemned by the pope.
1519–21 Ferdinand Magellan completes the first circumnavigation of the world.
Cortés destroys the Aztec Empire.

Essential Bibliography

Brambilla Barcilon, Pinin. *Leonardo: The Last Supper.* Chicago: University of Chicago Press, 2001.

Bramly, Serge. *Leonardo: Discovering the Life of Leonardo da Vinci.* New York: Edward Burlingame Books, 1991.

Brown, David Alan. *Leonardo da Vinci: Origins of a Genius.* New Haven: Yale University Press, 1998.

------, et al. *Virtue & Beauty: Leonardo's Ginevra de' Benci and Renaissance Portraits of Women.* Washington, D.C.: National Gallery of Art, 2001.

Clark, Kenneth. *Leonardo da Vinci.* London: Penguin Books, reprinted 1993.

Clayton, Martin. *Leonardo da Vinci: A Singular Vision.* New York: Abbeville Press, 1996.

Farago, Claire, ed. *Leonardo's Science and Technology.* New York: Garland, 1999.

Kemp, Martin. *Leonardo da Vinci: The Marvelous Works of Nature and Man.* London and Cambridge (Mass.), 1981.

------, ed. *Leonardo on Painting.* New Haven and London: Yale University Press, 1989.

MacCurdy, Edward. *The Notebooks of Leonardo da Vinci.* London: Cape, 1938.

Marani, Pietro C. *Leonardo da Vinci: The Complete Paintings.* New York: Abrams, 2000.

Masters, Roger D. *Fortune Is a River.* New York: Penguin Putnam, 1999.

McMahon, A., ed. *The Treatise on Painting.* Princeton, 1956.

Pedretti, Carlo. *The Codex Atlanticus of Leonardo da Vinci.* New York: Johnson Reprint, 1978–79.

------. *Leonardo: A Study in Chronology and Style.* London: Thames and Hudson, 1973.

------. *Leonardo, Architect.* New York: Rizzoli, 1985.

------. *Leonardo da Vinci: The Royal Palace at Romorantin.* Cambridge, Mass.: Harvard University Press, 1972.

------, ed. *The Literary Works of Leonardo da Vinci.* Berkeley: University of California Press, 1977.

Philipson, Morris, ed. *Leonardo da Vinci: Aspects of the Renaissance Genius.* New York: George Braziller, 1966.

Popham, A. E. *The Drawings of Leonardo da Vinci.* New York: Reynal & Hitchcock, 1945. Revised, 1994.

Reti, Ladislao, ed. *The Unknown Leonardo.* New York: McGraw-Hill, 1974.

Roberts, Jane, ed. *Leonardo da Vinci: The Codex Hammer, formerly the Codex Leicester.* London: Royal Academy of Arts, 1981.

Rowden, Maurice. *Leonardo da Vinci.* London: Widenfeld and Nicolson, 1975.

Vallentin, Antonia. *Leonardo da Vinci.* New York: Viking, 1938.

Vasari, Giorgio. *Lives of the Painters, Sculptors, and Architects.* New York, Toronto: Alfred A. Knopf, 1996.

Wasserman, Jack. *Leonardo da Vinci.* New York, 1975.

Zöllner, Frank. *Leonardo da Vinci: The Complete Paintings and Drawings.* Köln, London: Taschen, 2003.

Photo References

Archivio Scala Group, Antella; Archivio Electa, Milan; Corbis/Grazia Neri, Milan; Biblioteca Reale, Turin; Agence Photographique de la Reunion des Musées Nationaux, Paris; Archivio Musei Civici, Venice.

Leonardo da Vinci's Horse, Inc., through the kind courtesy of Snai Spa, Milan.
The Royal Collection © 2002, Her Majesty Queen Elizabeth II.

Through the kind courtesy of the Italian Ministry of Fine Arts the images provided by the following have been reproduced in this book: Soprintendenza per il Patrimonio Storico, Artistico e Demoetnoantropologico of Milan, Bergamo, Como, Lecco, Lodi, Pavia, Sondrio, Varese; Soprintendenza per il Patrimonio Storico, Artistico e Demoetnoantropologico of Venice.

© Daniel Spoerri, Andy Warhol, by S.I.A.E., 2002

Thanks also to the photographic archives of the museums and public and private associations that have provided material for illustrations.